"Drawing Games for Little Observers" is a collection of creative games designed to teach children how to draw by sharpening their observational skills. Each game encourages children to see drawing as a joyful exploration rather than a test of skill or accuracy. However, these games are not solo activities; they require the active participation of an adult to make the experience richer and more engaging. Together, the child and adult can embark on these games, discovering new ways to look at and interpret the world.

The aim of this approach is to help children understand that drawing is not simply about copying a photo or imitating an expert's artwork—both of which can feel daunting due to their precision or skill. Instead, these games show that drawing is about creating a unique interpretation of the world. By learning to observe without the pressure of achieving photographic realism, children realize that what they create is their own, unfiltered view—a "first-hand" interpretation. This understanding fosters confidence, as the child sees drawing not as a comparison to others' work but as a direct expression of their own perception.

Through these games, children begin to appreciate that drawing is a skill everyone can develop. It is less about perfection and more about the ability to see and capture what they notice, building self-assurance in their own abilities to interpret and represent the world around them.

A Note on How to Use This Book

"Drawing Games for Little Observers" is designed to be a flexible journey of creativity and observation. There is no specific order to follow—each page contains a unique game that can be explored at any time. Feel free to pick games that spark the most interest or try as many as you like. Repeating favorite games is encouraged, as the aim is to make drawing enjoyable and engaging for both the child and adult.

This book is about having fun while learning to see the world differently. If you and your child come up with your own drawing games, that's even better! The main goal is to foster observation, build confidence, and show that drawing isn't as daunting as it seems. It's all about exploring together, interpreting the world in your own way, and enjoying the creative process.

LOOK THROUGH THE TUBE

RULES:

The adult points to an item (for example, a vase) for the child to observe.
The adult asks the child to frame the item by looking through the tube.

WHAT WE'RE LEARNING:
Through this game, the child learns that to frame an object within the tube; one either needs to move closer to or further away from the object. This game underscores the idea that perception is influenced by one's viewpoint, which in turn, affects the size of the objects being observed. Objects appear smaller the further away they are.

ALTERNATIVE TO TRY
Instead of pointing to a fixed object, hold a pen and move it to different spots around the room. Switch roles so the child moves the pen while the adult tries to frame it through the tube.

WHAT'S IN THE BAG?

RULES

THE ADULT SHOWS THE CHILD THREE ITEMS AND THEN PLACES THEM INTO A BAG. THE ADULT NAMES ONE ITEM, AND THE CHILD NEEDS TO FIND THE ITEM FROM THE BAG USING ONLY THE SENSE OF TOUCH.

WHAT WE'RE LEARNING:

WHEN WE DRAW, WE AIM TO CAPTURE NOT JUST HOW SOMETHING LOOKS BUT ALSO HOW IT FEELS-WHETHER IT'S HARD, SOFT, ROUGH, OR SMOOTH. THIS IS SOMETIMES CALLED "HAPTIC VISION," WHERE WHAT WE SEE FEELS ALMOST TOUCHABLE. THIS GAME IS A FUN WAY TO CONNECT OUR SENSE OF TOUCH WITH HOW WE SEE SHAPES AND TEXTURES.

ALTERNATIVE TO TRY:

Taking turns... Now the child hides the items in the bag and asks the adult to find one.
Try drawing one of the items on paper.

SHADE OF GREY

RULES

THE ADULT DRAWS A PATCH IN A SPECIFIC SHADE OF GREY, USING EVEN PRESSURE.
THE CHILD TRIES TO MATCH THE SAME SHADE USING A PENCIL.

WHAT WE'RE LEARNING:

THIS GAME INTRODUCES GREYSCALE AND HOW LIGHT AND SHADOW EFFECT DRAWING. IT'S A SIMPLE WAY TO EXPLORE 'SHADE CONSTANCY'- HOW WE SEE SHADES DIFFERENTLY BASED ON LIGHT AND SURROUNDINGS. THE AIM IS TO KEEP IT FUN AND STRESS-FREE, FOCUSING ON LEARNING AND ENJOYMENT, NOT PERFECTION.

ALTERNATIVE TO TRY:

Advanced learners can use software like Photoshop to check grey tone accuracy. Or, try drawing the shadow of an object cast on a table for variation.

COLOUR MATCH

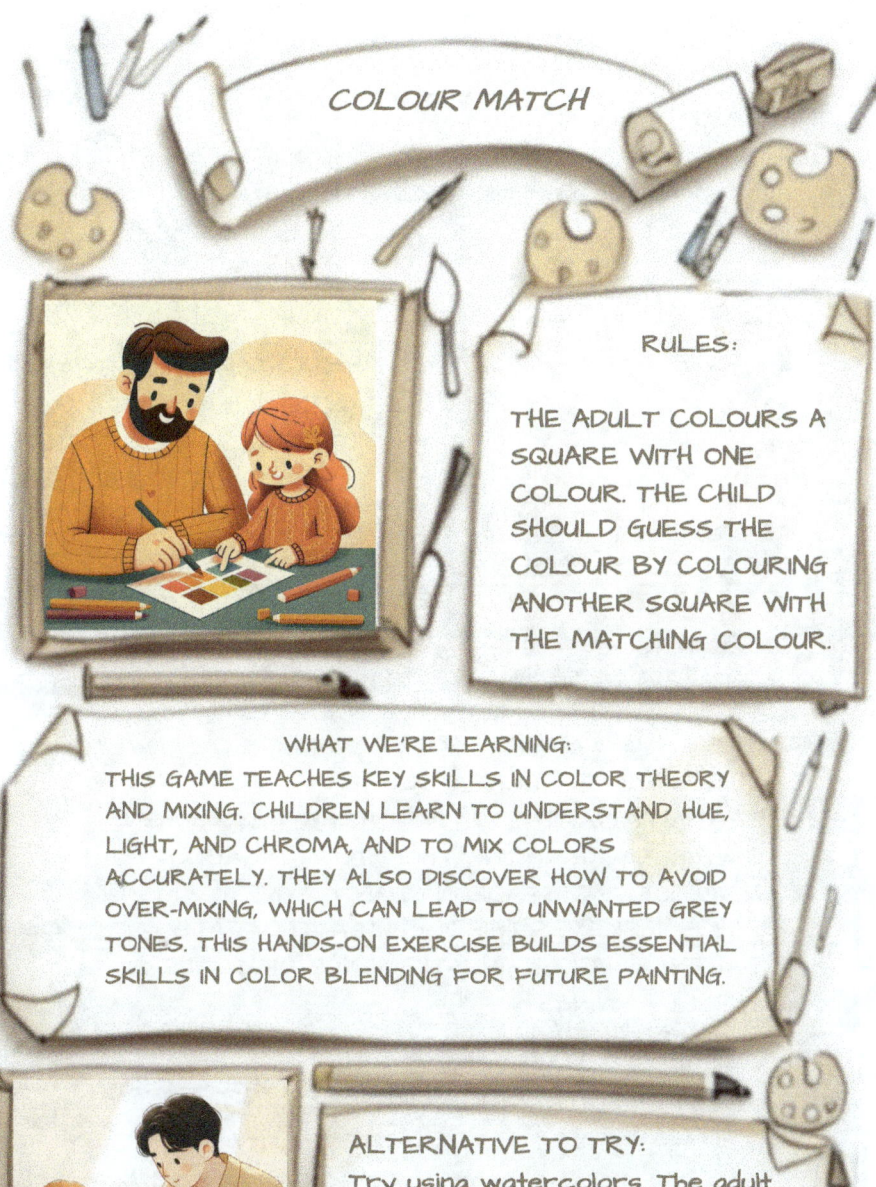

RULES:

The adult colours a square with one colour. The child should guess the colour by colouring another square with the matching colour.

WHAT WE'RE LEARNING:

This game teaches key skills in color theory and mixing. Children learn to understand hue, light, and chroma, and to mix colors accurately. They also discover how to avoid over-mixing, which can lead to unwanted grey tones. This hands-on exercise builds essential skills in color blending for future painting.

ALTERNATIVE TO TRY:

Try using watercolors. The adult mixes two colors out of the child's sight (a little peeking is fine). The child then tries to recreate the same color by mixing their own.

HOW FAR IS IT?

RULES
THE ADULT PLACES TWO OBJECTS AT A CERTAIN DISTANCE FROM EACH OTHER. THE ADULT ASKS THE CHILD TO ESTIMATE THE DISTANCE BETWEEN THE TWO OBJECTS IN EITHER CENTIMETERS OR STEPS.

WHAT WE'RE LEARNING:
THIS EXERCISE HELPS CHILDREN DEVELOP SPATIAL AWARENESS AND BASIC MEASUREMENT SKILLS, ENCOURAGING THEM TO THINK ABOUT DISTANCE AND SPACE IN QUANTITATIVE TERMS, WHICH IMPROVES THEIR ABILITY TO CREATE BALANCED AND REALISTIC SENSE OF SCALE IN THEIR DRAWINGS.

ALTERNATIVE TO TRY:
After the child estimates, let them place the objects and have the adult guess the distance.
Or, try estimating distances of objects seen from a window.

HOLDING ITEMS

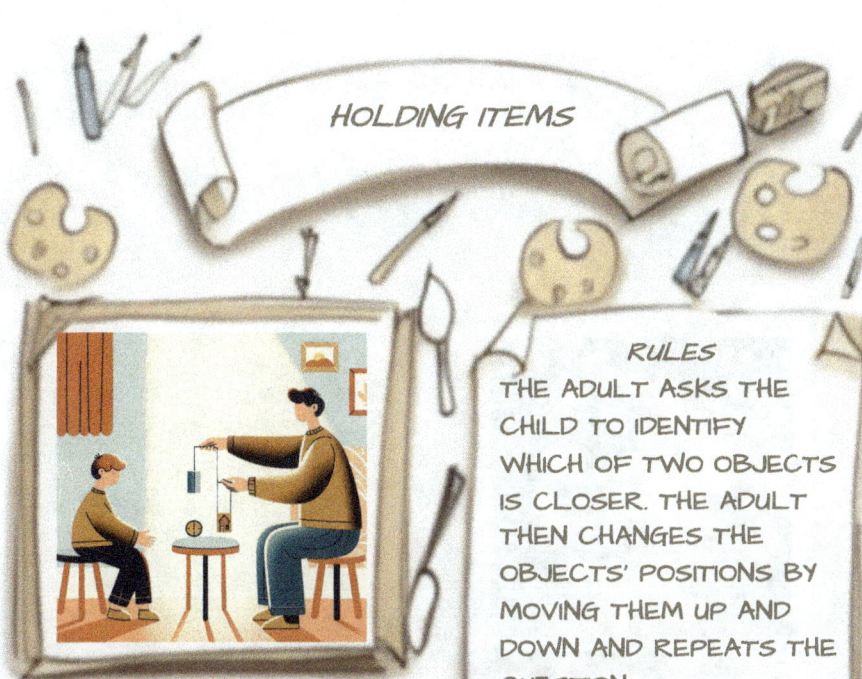

RULES
THE ADULT ASKS THE CHILD TO IDENTIFY WHICH OF TWO OBJECTS IS CLOSER. THE ADULT THEN CHANGES THE OBJECTS' POSITIONS BY MOVING THEM UP AND DOWN AND REPEATS THE QUESTION.

WHAT WE'RE LEARNING:
THIS EXERCISE HELPS CHILDREN EXPLORE PERSPECTIVE AND OVERLAPPING IN THEIR DRAWINGS, ESSENTIAL SKILLS FOR SHOWING DEPTH AND SPATIAL RELATIONSHIPS. WHEN ONE OBJECT OVERLAPS ANOTHER, IT INDICATES WHICH IS CLOSER, ENHANCING THEIR UNDERSTANDING OF POSITIONING IN LIFE DRAWING.

ALTERNATIVE TO TRY:
When objects overlap, ask the child why one seems behind the other. Add a third object on the floor to explore more complex arrangements and perspectives.

SHADOW SHAPES

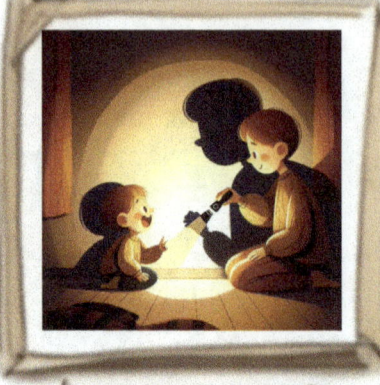

RULES

In a dimly lit room, the adult shines a flashlight on an object to cast its shadow on the wall or paper. The child observes the shadow and guesses the object creating it.

WHAT WE'RE LEARNING:

This exercise teaches the basics of light and shadow, showing how distance and angle change shadow size and shape. It encourages creativity in interpreting shadow shapes, and the shadow storytelling option builds narrative skills and creative expression.

ALTERNATIVE TO TRY:

Create a story or scene using different object shadows to boost creativity and storytelling. Trace and color the shadows on paper to turn it into an art activity.

SHADOW THEATRE

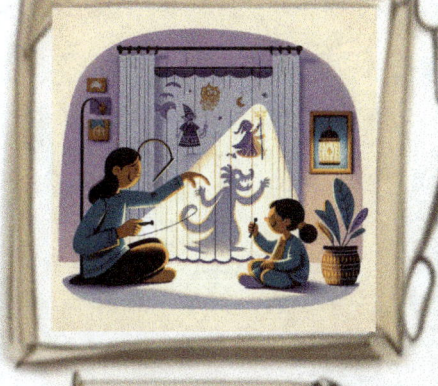

RULES

Make shadows into fun scenes, like a monster chasing the child. Experiment with how shadows change on different surfaces- try a curved surface, or a curtain, for unique effects.

WHAT WE'RE LEARNING:

This exercise teaches about silhouettes by focusing on the contour and main shape of objects. Children learn how shapes change with different projection angles, like a circle becoming an oval. Additionally the game encourages imagination and creativity through shadow play.

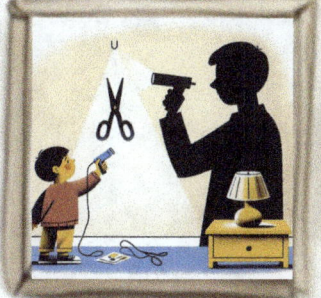

ALTERNATIVE TO TRY:

Project the shadow of an object without showing the actual object and ask the child to guess what it is. For example, "What is it? It's scissors."

POINTS AND LINES

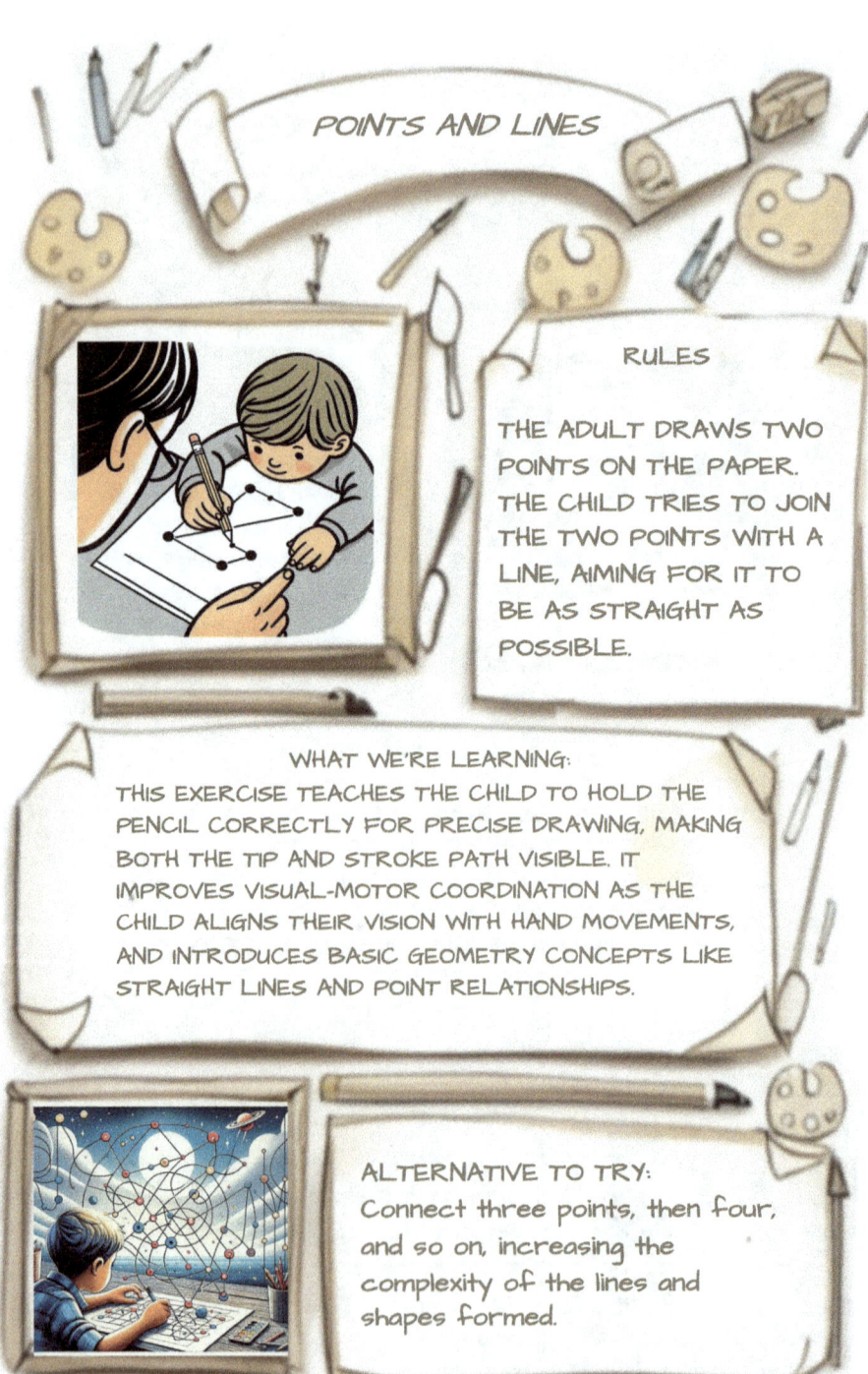

RULES

The adult draws two points on the paper. The child tries to join the two points with a line, aiming for it to be as straight as possible.

WHAT WE'RE LEARNING:

This exercise teaches the child to hold the pencil correctly for precise drawing, making both the tip and stroke path visible. It improves visual-motor coordination as the child aligns their vision with hand movements, and introduces basic geometry concepts like straight lines and point relationships.

ALTERNATIVE TO TRY:

Connect three points, then four, and so on, increasing the complexity of the lines and shapes formed.

FRAMING

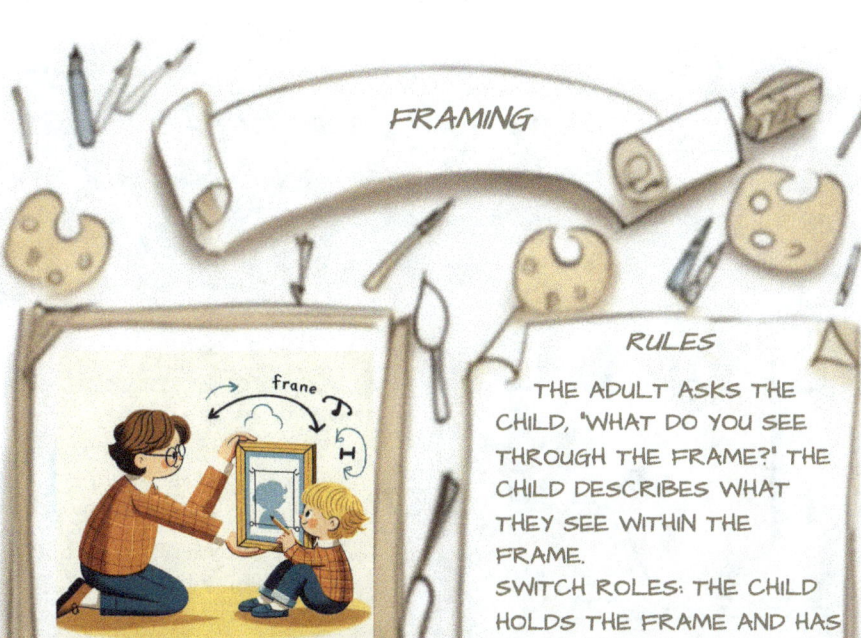

RULES

The adult asks the child, "What do you see through the frame?" The child describes what they see within the frame.
Switch roles: the child holds the frame and has the adult describe what they see.

WHAT WE'RE LEARNING:

This game introduces framing and composition in visual arts. It teaches different perspectives, both physically and conceptually, by helping the child understand what others see. It also builds spatial skills as the child learns to interpret and adjust objects within the frame.

ALTERNATIVE TO TRY:

Recognise and use frames present in everyday life, such as train windows, car windows, or house windows, to frame different scenes and objects.

DRAWING WITH YOUR FEET

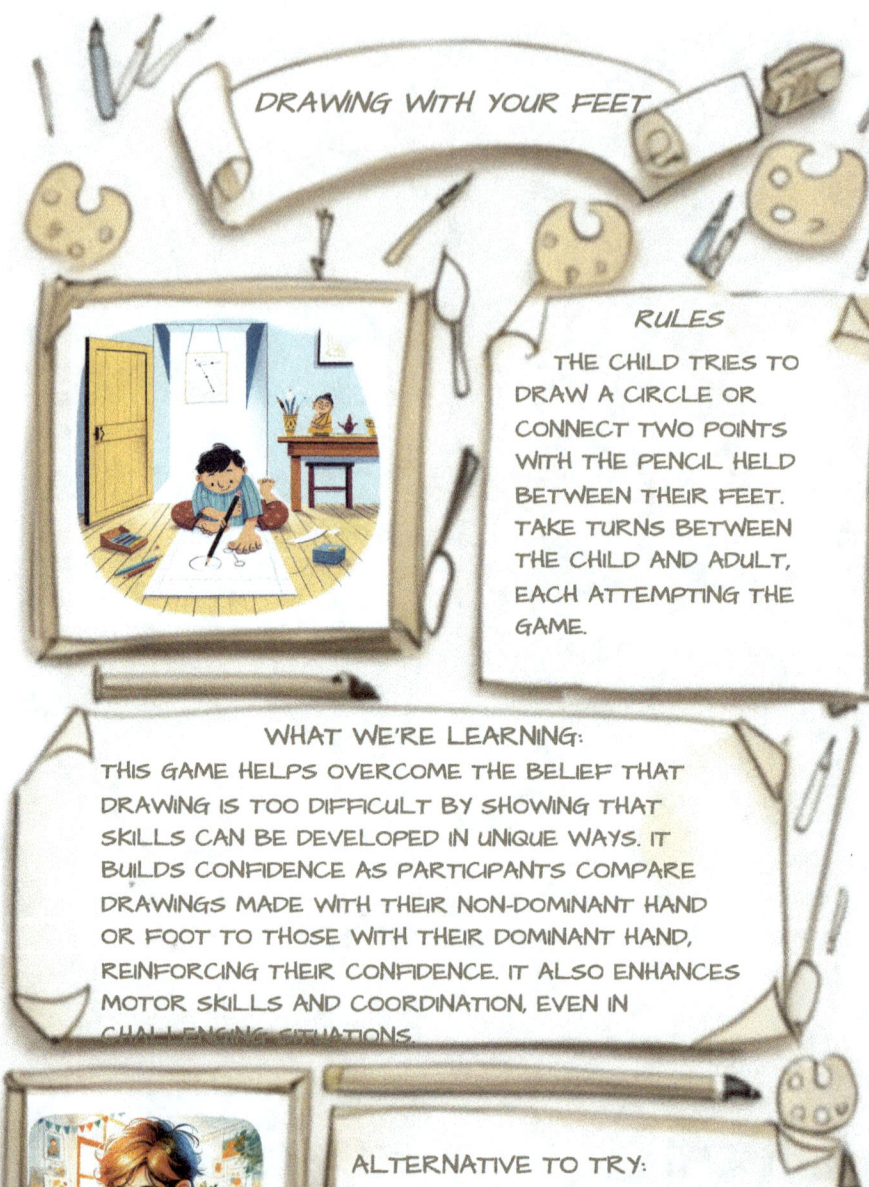

RULES

The child tries to draw a circle or connect two points with the pencil held between their feet. Take turns between the child and adult, each attempting the game.

WHAT WE'RE LEARNING:

This game helps overcome the belief that drawing is too difficult by showing that skills can be developed in unique ways. It builds confidence as participants compare drawings made with their non-dominant hand or foot to those with their dominant hand, reinforcing their confidence. It also enhances motor skills and coordination, even in challenging situations.

ALTERNATIVE TO TRY:

Try drawing with the non-dominant hand: left-handed individuals use the right, and right-handed individuals use the left.

GUESS WHAT I DRAW

RULES

The adult draws an object they see in the room. The child then has to guess what object it is by pointing to it in the room. Alternate turns between the adult and the child, with one drawing and the other guessing.

WHAT WE'RE LEARNING:

This game builds confidence in drawing real objects, helping participants accept that drawings don't need to be perfect. It also reduces shyness about drawing in front of others and improves observational skills by translating real objects onto paper, no matter the skill level.

ALTERNATIVE TO TRY

Instead of objects in the room, draw objects that are visible outside the window.

FOLLOW MY FINGER

RULES

THE ADULT TRACES THE CONTOUR OF AN OBJECT BY MOVING THEIR FINGER ALONG ITS EDGES. THE CHILD FOLLOWS THIS MOVEMENT BY TRACING THE CONTOUR ON PAPER WITH A PENCIL, MIMICKING THE ADULT'S FINGER AS IT MOVES.

WHAT WE'RE LEARNING:

THIS EXERCISE TEACHES HOW TO CLOSELY FOLLOW AN OBJECT'S LINES, A SKILL EVEN CHALLENGING FOR EXPERIENCED ARTISTS. IT SHARPENS OBSERVATION AND ACCURACY IN REPLICATING CONTOURS AND INTRODUCES THE IDEA OF NATURAL LINE RHYTHMS, ENCOURAGING AN APPRECIATION FOR THE BEAUTY AND COMPLEXITY OF NATURE'S LINES OVER SIMPLE, MENTAL SHORTCUTS.

ALTERNATIVE TO TRY:

Place the object directly on the sheet and trace its contours, similar to making a handprint

FIND ME ON THE MAP

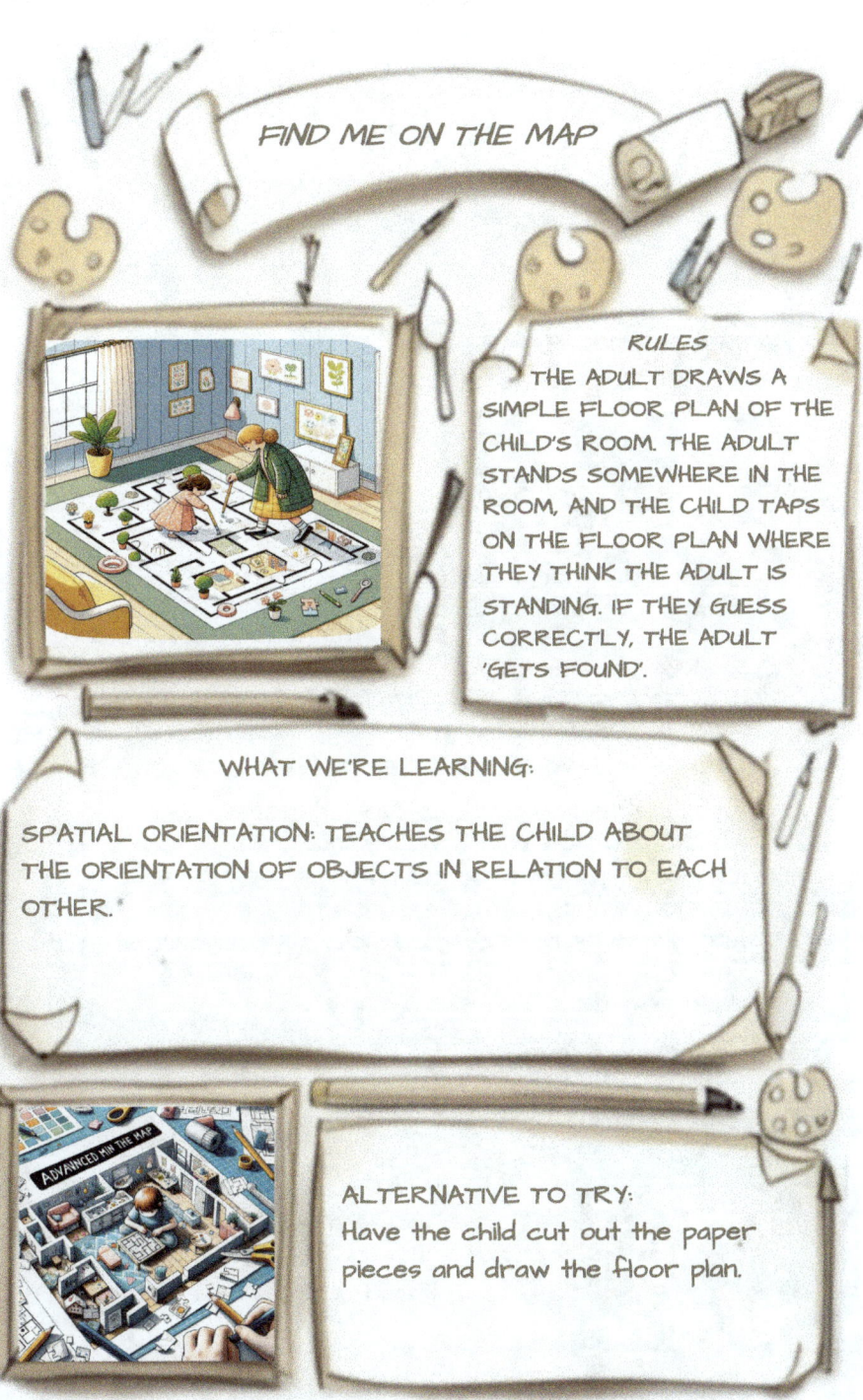

RULES
The adult draws a simple floor plan of the child's room. The adult stands somewhere in the room, and the child taps on the floor plan where they think the adult is standing. If they guess correctly, the adult 'gets found'.

WHAT WE'RE LEARNING:

Spatial Orientation: Teaches the child about the orientation of objects in relation to each other.

ALTERNATIVE TO TRY:
Have the child cut out the paper pieces and draw the floor plan.

FACE UP DOWN

RULES

THE ADULT MOVES A CUBE (OR ANY SIX-FACED OBJECT) UP AND DOWN IN FRONT OF THE CHILD. THE CHILD OBSERVES WHICH FACES ARE VISIBLE FROM DIFFERENT ANGLES, LEARNING HOW THE VIEW CHANGES WHEN LOOKING FROM ABOVE OR BELOW.

WHAT WE'RE LEARNING:

THIS EXERCISE INTRODUCES BASIC PERSPECTIVE IN A FUN, HANDS-ON WAY. IT HELPS THE CHILD UNDERSTAND HOW DIFFERENT FACES OF A CUBE APPEAR OR DISAPPEAR BASED ON THEIR POSITION AND IMPROVES OBSERVATION SKILLS BY TEACHING THAT ONLY UP TO THREE FACES OF A CUBE ARE VISIBLE AT ONCE.

ALTERNATIVE TO TRY:

Use a dice and ask the child to guess the number on the hidden face based on the visible faces

CIRCLE AND OVAL

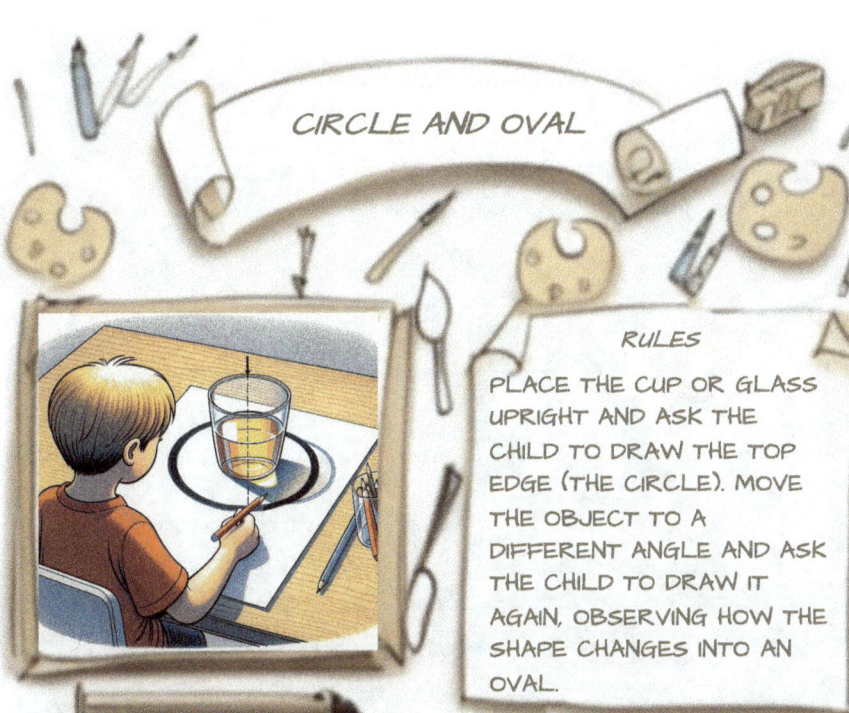

RULES

PLACE THE CUP OR GLASS UPRIGHT AND ASK THE CHILD TO DRAW THE TOP EDGE (THE CIRCLE). MOVE THE OBJECT TO A DIFFERENT ANGLE AND ASK THE CHILD TO DRAW IT AGAIN, OBSERVING HOW THE SHAPE CHANGES INTO AN OVAL.

WHAT WE'RE LEARNING:

THIS GAME TEACHES THE CHILD HOW A CIRCLE CHANGES INTO AN OVAL WHEN VIEWED FROM DIFFERENT ANGLES, SHOWING HOW SHAPES TRANSFORM BASED ON POSITION AND PERSPECTIVE. FOR EXAMPLE, A CIRCLE MAY APPEAR AS A STRAIGHT LINE WHEN ON THE HORIZON

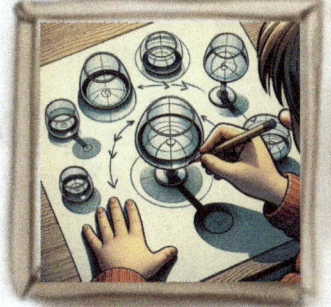

ALTERNATIVE TO TRY:
Instead of just the top edge, ask the child to draw the entire glass from different angles.

BE ORGANISED

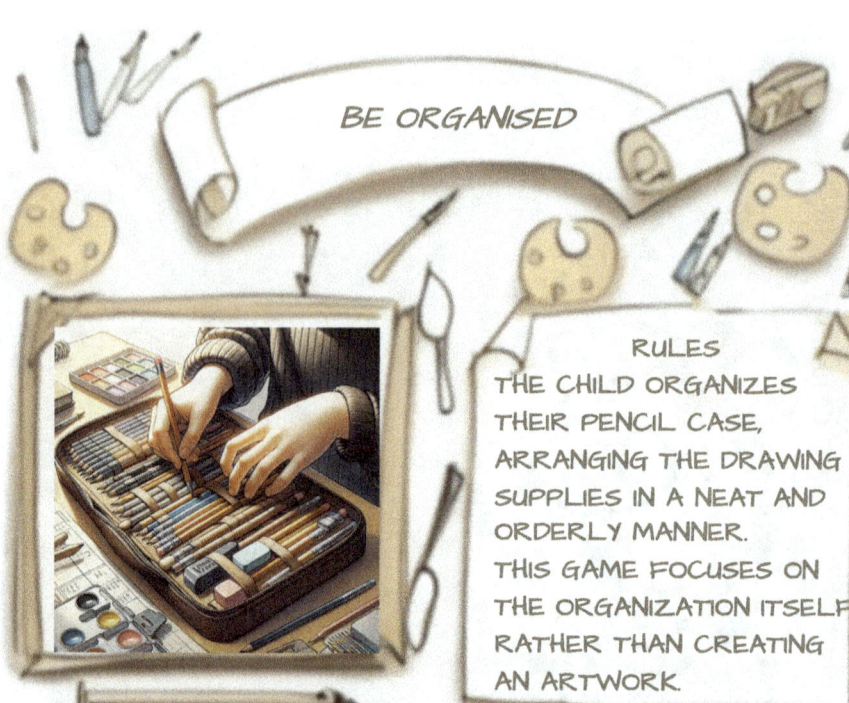

RULES
THE CHILD ORGANIZES THEIR PENCIL CASE, ARRANGING THE DRAWING SUPPLIES IN A NEAT AND ORDERLY MANNER.
THIS GAME FOCUSES ON THE ORGANIZATION ITSELF RATHER THAN CREATING AN ARTWORK.

WHAT WE'RE LEARNING:
THIS GAME HIGHLIGHTS THE IMPORTANCE OF ORGANIZATION IN ART, SHOWING HOW KEEPING SUPPLIES ORDERLY HELPS IN CREATIVE ACTIVITIES, LIKE ARRANGING COLORS OR MAINTAINING CLEAN BRUSHES. IT IMPROVES MEMORY AND ATTENTION TO DETAIL AND ENCOURAGES GOOD HABITS IN CARING FOR AND ORGANIZING ART SUPPLIES, AN ESSENTIAL SKILL FOR ANY ARTIST.

ALTERNATIVE TO TRY:
After the child has organized the pencil case, ask them to recall and list the items in their pencil case without looking.

COLLAGE

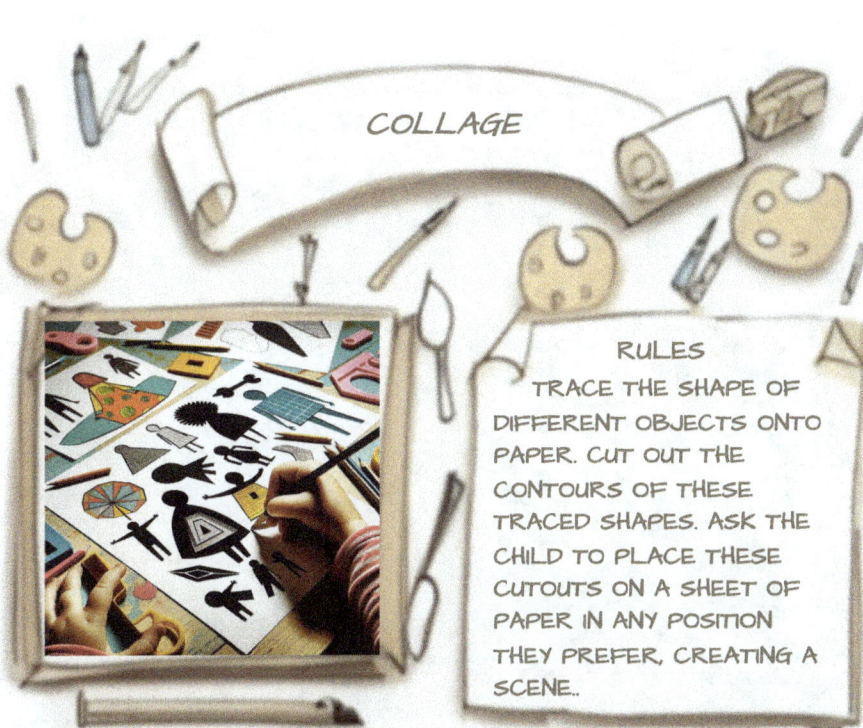

RULES
Trace the shape of different objects onto paper. Cut out the contours of these traced shapes. Ask the child to place these cutouts on a sheet of paper in any position they prefer, creating a scene..

WHAT WE'RE LEARNING:
This exercise teaches the child about the importance of an object's silhouette, a key concept in drawing, comics, and animation. It enhances spatial awareness by showing how shapes occupy space and interact within a frame. The activity also encourages creativity and composition, as the child arranges cutout shapes to create a unique scene.

ALTERNATIVE TO TRY:
Use glue to stick the cutouts onto the paper, turning the activity into a collage-making exercise.

NEGATIVE SHAPES

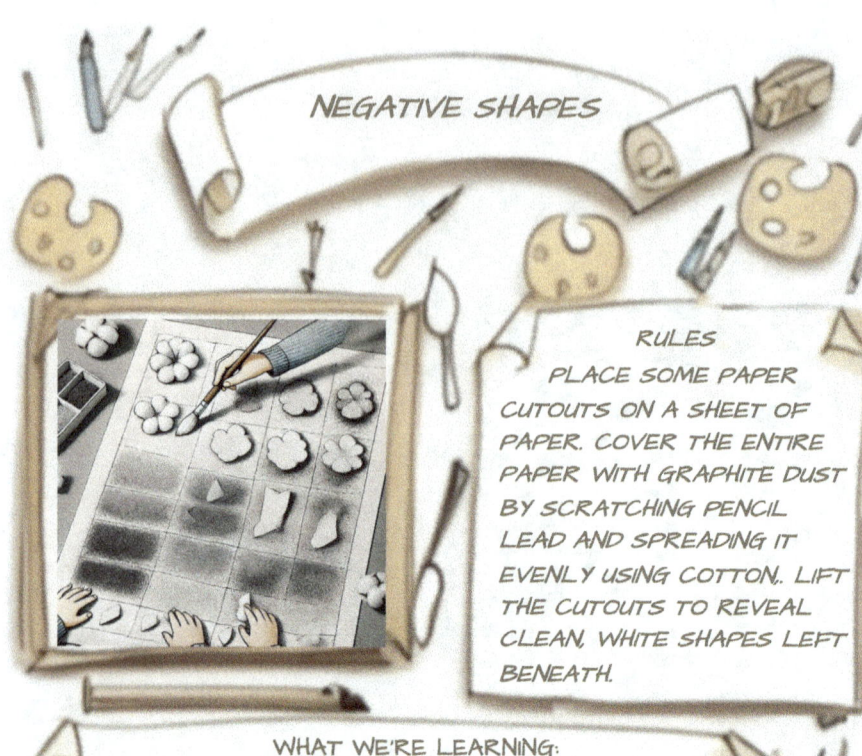

RULES
Place some paper cutouts on a sheet of paper. Cover the entire paper with graphite dust by scratching pencil lead and spreading it evenly using cotton. Lift the cutouts to reveal clean, white shapes left beneath.

WHAT WE'RE LEARNING:
This game teaches positive and negative shapes in art, showing the importance of both the subject and surrounding space. It improves visual perception by encouraging children to see shapes and spaces in new ways and introduces a creative, hands-on technique for making art with simple materials.

ALTERNATIVE TO TRY:
Sprinkle some talcum powder over the lead dust before rubbing it to create a more pronounced and voluminous effect.

PADDLES

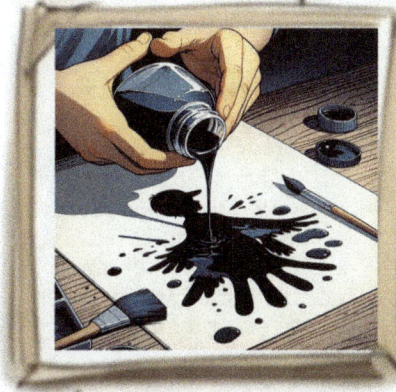

RULES
POUR A SMALL PUDDLE OF BLACK INK ONTO A SHEET OF PAPER. CHOOSE A LIVE OBJECT TO OBSERVE AND USE A BRUSH TO MOVE THE INK BLOB AROUND, SHAPING IT TO MATCH THE OBJECT'S SILHOUETTE. FOCUS ON CAPTURING THE SHAPE AND PROPORTIONS.

WHAT WE'RE LEARNING:
THIS EXERCISE TEACHES HOW TO DRAW OBJECT SILHOUETTES, A BASIC ART SKILL. IT HELPS CHILDREN UNDERSTAND PROPORTIONS AND HOW TO ARRANGE OBJECTS BASED ON THE SPACE THEY OCCUPY. IT ALSO INTRODUCES THE CONCEPT OF POSITIVE AND NEGATIVE SHAPES, DEEPENING THEIR UNDERSTANDING OF COMPOSITION IN ART.

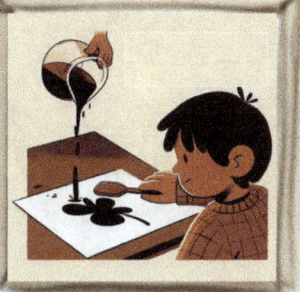

ALTERNATIVE TO TRY:
If black ink is not available, dirty coffee water can be used as a substitute to create dark shapes and silhouettes.

HORIZON HUNT

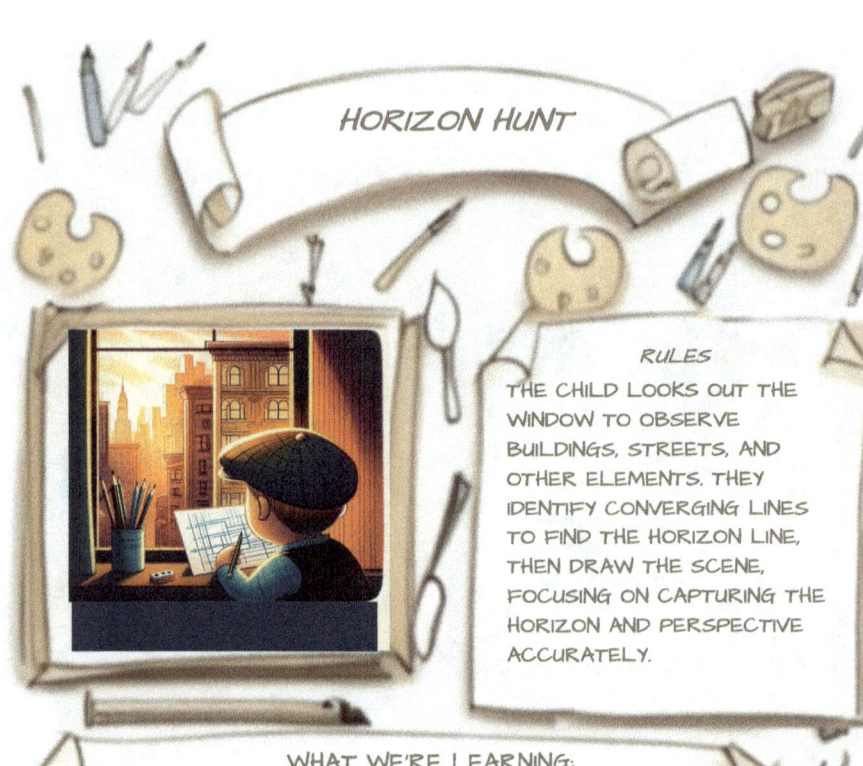

RULES
THE CHILD LOOKS OUT THE WINDOW TO OBSERVE BUILDINGS, STREETS, AND OTHER ELEMENTS. THEY IDENTIFY CONVERGING LINES TO FIND THE HORIZON LINE, THEN DRAW THE SCENE, FOCUSING ON CAPTURING THE HORIZON AND PERSPECTIVE ACCURATELY.

WHAT WE'RE LEARNING:
THIS GAME TEACHES PERSPECTIVE, SHOWING THE IMPORTANCE OF THE HORIZON LINE IN CREATING DEPTH. IT IMPROVES OBSERVATION SKILLS, HELPING THE CHILD SEE HOW LINES AND ANGLES BUILD A SENSE OF SPACE. IT ALSO ENCOURAGES THEM TO THINK ABOUT THE POINT OF VIEW IN CREATING A SCENE.

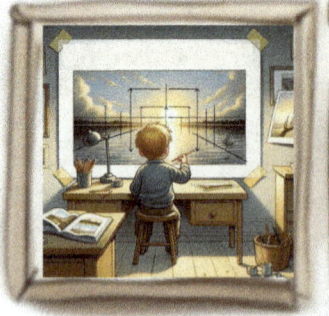

ALTERNATIVE TO TRY:
Instead of looking out a window, the child finds the horizon line and perspective lines in a photograph or picture, learning to identify these elements in different visual mediums.

LARGE CANVAS

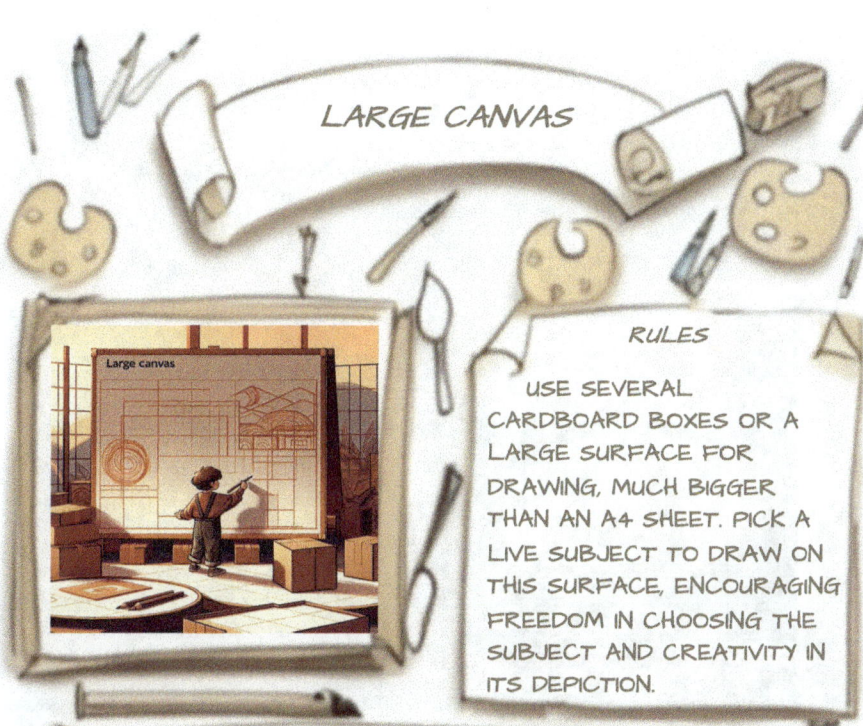

RULES

Use several cardboard boxes or a large surface for drawing, much bigger than an A4 sheet. Pick a live subject to draw on this surface, encouraging freedom in choosing the subject and creativity in its depiction.

WHAT WE'RE LEARNING:

This game teaches children to adapt to drawing on different scales. It enhances spatial awareness by requiring them to step back and view the artwork as a whole. It also shows how the size of the canvas affects the impact and perception of their drawings, offering a fresh perspective on artistic expression.

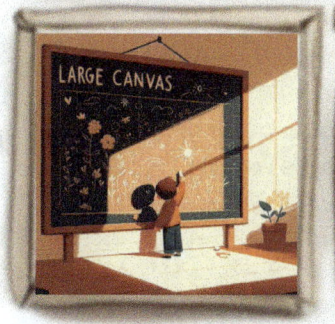

ALTERNATIVE TO TRY:

Instead of using cardboard boxes, use a blackboard to draw the subject. This provides a different texture and experience, using chalk instead of pencils or markers.

BALANCE

RULES
Hang the cloth hanger on a window frame. Attach items on both sides of the hanger, trying to keep it balanced. Once a balanced composition is achieved, move away to view the composition from a distance.

WHAT WE'RE LEARNING:
This exercise teaches visual balance by linking the physical act of balancing items with how we perceive balance in compositions. It improves spatial awareness, helping the child understand how object placement affects visual impact. It also fosters creativity in selecting items and problem-solving to achieve a balanced arrangement.

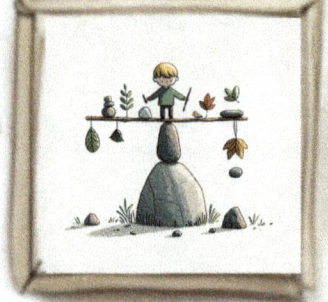

ALTERNATIVE TO TRY:
Perform the game outdoors using a stick. Place the stick on top of a rock, acting as a wedge, and balance items on either end of the stick.

TRANSPARENT TALES

RULES
PUT A PENCIL INSIDE A GLASS FILLED WITH WATER AND HAVE THE CHILD LOOK THROUGH THE WATER TO OBSERVE HOW THE PENCIL APPEARS DISTORTED. THE CHILD THEN DRAWS WHAT THEY SEE ON THE PAPER, FOCUSING ON CAPTURING THE DISTORTIONS.

WHAT WE'RE LEARNING:
THIS EXERCISE TEACHES HOW TRANSPARENCY AND REFRACTION CAN DISTORT OBJECTS, SHOWING HOW LIGHT INTERACTS WITH CLEAR MATERIALS TO CREATE UNIQUE EFFECTS. IT ENCOURAGES CREATIVITY BY ALLOWING THE CHILD TO INTERPRET AND EXPRESS THESE CHANGES, ENHANCING THEIR ARTISTIC SKILLS AND IMAGINATION.

ALTERNATIVE TO TRY:
Shine a light through the transparent objects to create interesting shadows and reflections on the paper, which the child can then trace or incorporate into their artwork.

TOY PORTRAIT

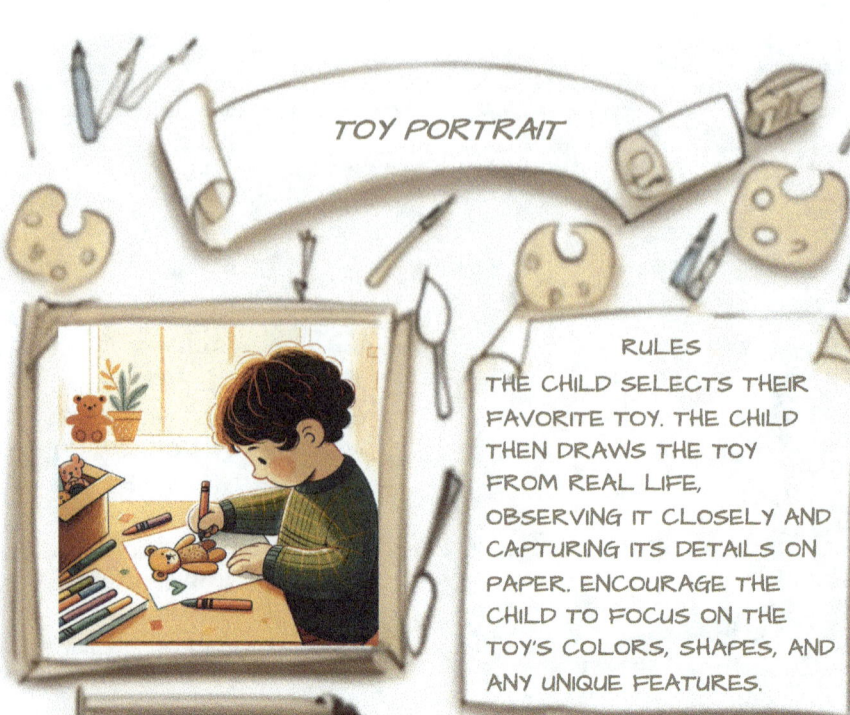

RULES
THE CHILD SELECTS THEIR FAVORITE TOY. THE CHILD THEN DRAWS THE TOY FROM REAL LIFE, OBSERVING IT CLOSELY AND CAPTURING ITS DETAILS ON PAPER. ENCOURAGE THE CHILD TO FOCUS ON THE TOY'S COLORS, SHAPES, AND ANY UNIQUE FEATURES.

WHAT WE'RE LEARNING:

THIS EXERCISE IMPROVES OBSERVATION AND ATTENTION TO DETAIL BY DRAWING A FAMILIAR OBJECT. IT ENCOURAGES THE CHILD TO EXPRESS THEIR CONNECTION TO THE TOY, BRINGING OUT EMOTIONS AND MEMORIES.

ALTERNATIVE TO TRY:
After drawing the toy, the child can create a background or a scene around the toy, effectively placing it in a story or an imaginative setting.

THE MIRROR CHALLENGE

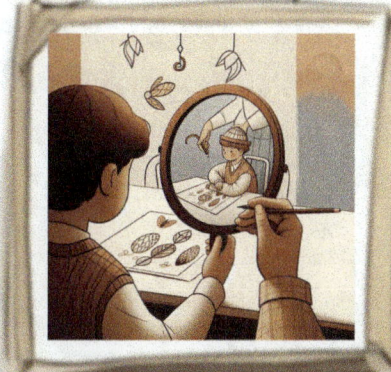

RULES

The child draws an item on the paper, the child looks at it in the mirror. The adult then holds the drawing in front of the mirror, and the child attempts to draw the mirror image of their original drawing.

WHAT WE'RE LEARNING:

This exercise teaches symmetry, helping children see how drawings may appear symmetrical but often aren't. It improves observation skills by encouraging them to notice subtle imbalances. Using a mirror allows them to view their work from a new perspective, helping them identify and correct errors.

ALTERNATIVE TO TRY:

If you have a small mirror, place it perpendicular to the eyes at nose level and look at the drawing through it. This technique helps check the symmetry of the drawing without moving the mirror in front of it.

CLAY TO SKETCH

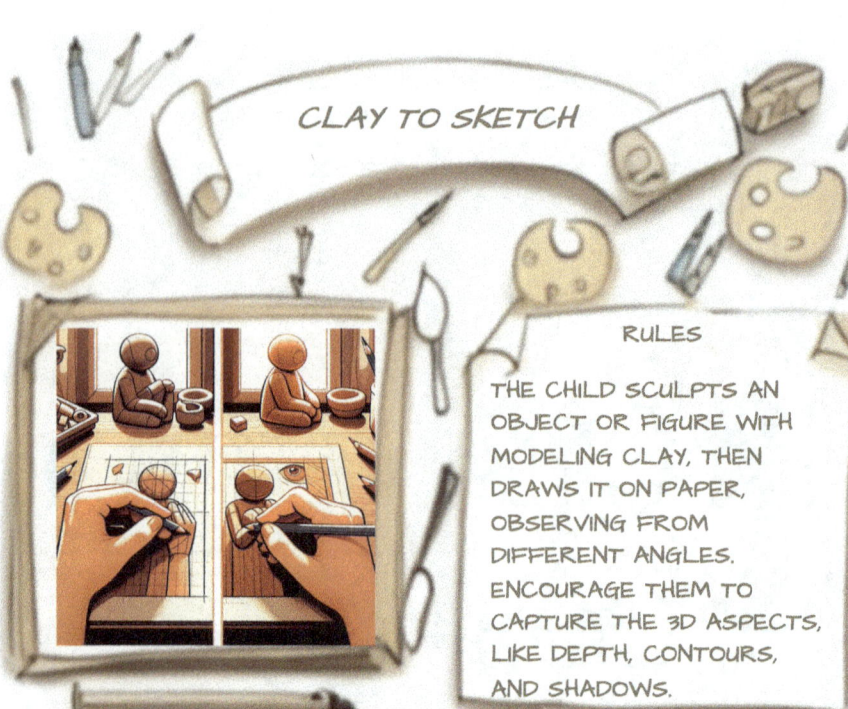

RULES

THE CHILD SCULPTS AN OBJECT OR FIGURE WITH MODELING CLAY, THEN DRAWS IT ON PAPER, OBSERVING FROM DIFFERENT ANGLES. ENCOURAGE THEM TO CAPTURE THE 3D ASPECTS, LIKE DEPTH, CONTOURS, AND SHADOWS.

WHAT WE'RE LEARNING:

THIS GAME TEACHES THE CHILD ABOUT 3D FORMS AND HOW TO TRANSLATE THEM INTO 2D DRAWINGS, BUILDING SPATIAL AWARENESS AND DEPTH PERCEPTION. IT ENHANCES OBSERVATION AND MEMORY SKILLS AND ENCOURAGES CREATIVITY IN BOTH SCULPTING AND DRAWING, ALLOWING EXPRESSION IN MULTIPLE DIMENSIONS.

ALTERNATIVE TO TRY:

After sculpting the object, have the child put it aside and then draw it from memory. This enhances their memory and understanding of spatial relationships and form.

BOXED POSES

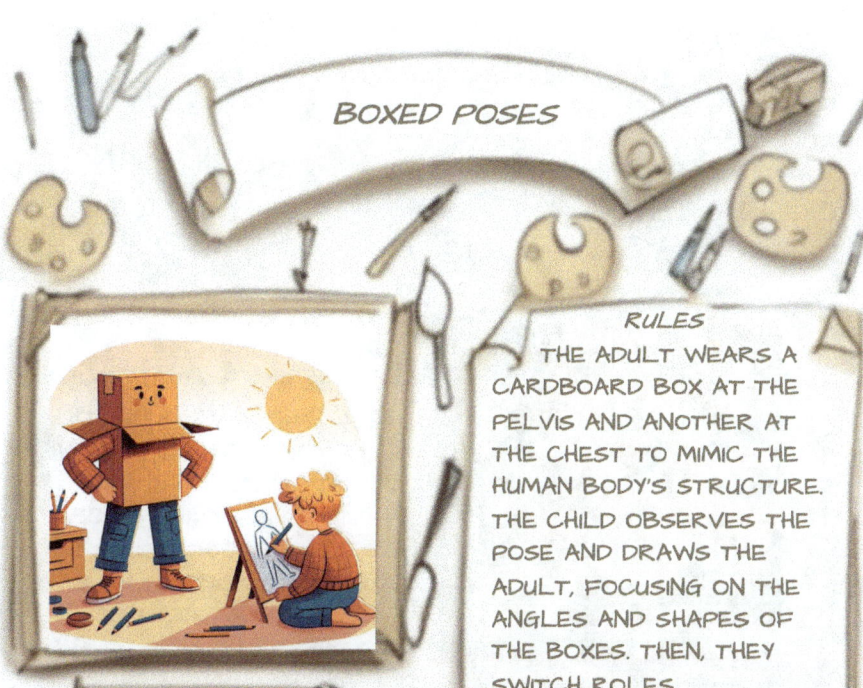

RULES

The adult wears a cardboard box at the pelvis and another at the chest to mimic the human body's structure. The child observes the pose and draws the adult, focusing on the angles and shapes of the boxes. Then, they switch roles.

WHAT WE'RE LEARNING:

This exercise helps children learn to draw the human figure by focusing on volume and structure. It improves spatial awareness, understanding of proportions, and observational skills by translating 3D shapes into 2D drawings.

ALTERNATIVE TO TRY:

Experiment with different dynamic poses, such as bending, twisting, or stretching, to understand how body volumes change with movement.

CUBE PERSPECTIVE

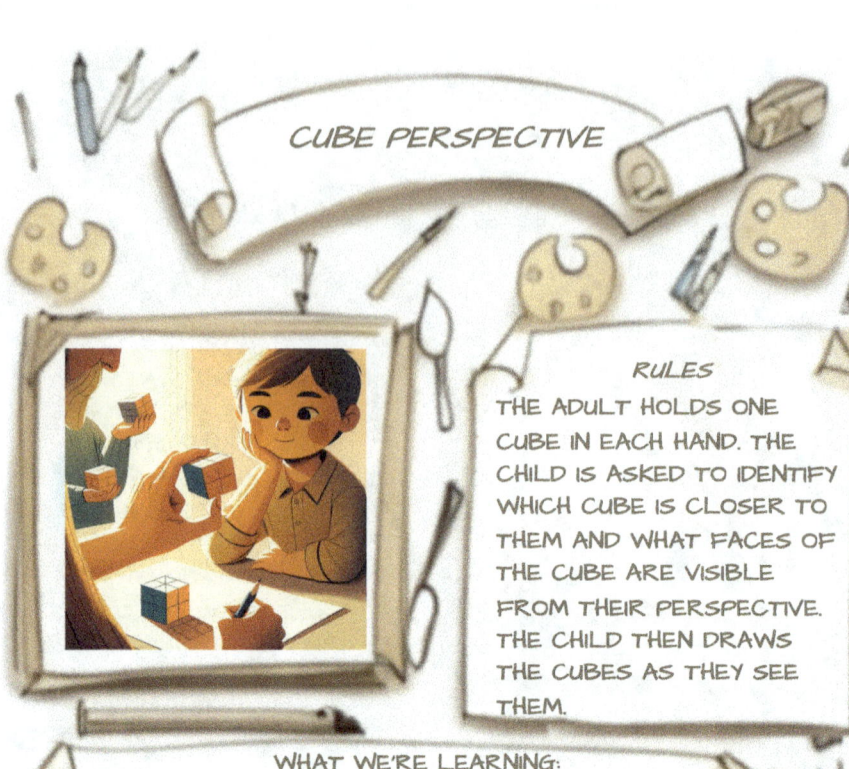

RULES

THE ADULT HOLDS ONE CUBE IN EACH HAND. THE CHILD IS ASKED TO IDENTIFY WHICH CUBE IS CLOSER TO THEM AND WHAT FACES OF THE CUBE ARE VISIBLE FROM THEIR PERSPECTIVE. THE CHILD THEN DRAWS THE CUBES AS THEY SEE THEM.

WHAT WE'RE LEARNING:

THIS GAME TEACHES PERSPECTIVE, SHOWING HOW DISTANCE AND ANGLE AFFECT HOW OBJECTS LOOK. IT BUILDS SPATIAL AWARENESS AND HELPS CHILDREN TRANSLATE 3D OBJECTS ONTO PAPER, ENHANCING THEIR OBSERVATIONAL DRAWING SKILLS.

ALTERNATIVE TO TRY:

Make the game more challenging by having the adult rotate the cubes in different ways. This change in orientation will alter the perspective and the visible faces of the cubes, providing a more complex drawing challenge.

WIRE WONDERS

RULES

THE ADULT SHAPES A WIRE INTO A SIMPLE, TWISTED STRUCTURE. THE CHILD OBSERVES AND DRAWS IT, FOCUSING ON THE TWISTS, OVERLAPS, AND CONTINUITY OF THE WIRE LINE.

WHAT WE'RE LEARNING:

THIS EXERCISE TEACHES HOW TO DRAW OVERLAPPING STRUCTURES AND UNDERSTAND SPATIAL RELATIONSHIPS. IT ENHANCES OBSERVATION SKILLS BY FOCUSING ON THE WIRE'S CONTINUITY AND DETAIL, AND IT IMPROVES THE CHILD'S ABILITY TO REPRESENT 3D OBJECTS ON PAPER.

ALTERNATIVE TO TRY:

Increase the complexity of the wire structure by creating more complicated knots and bends. This variation challenges the child to observe and represent more intricate details and spatial relationships.

RULER LINES

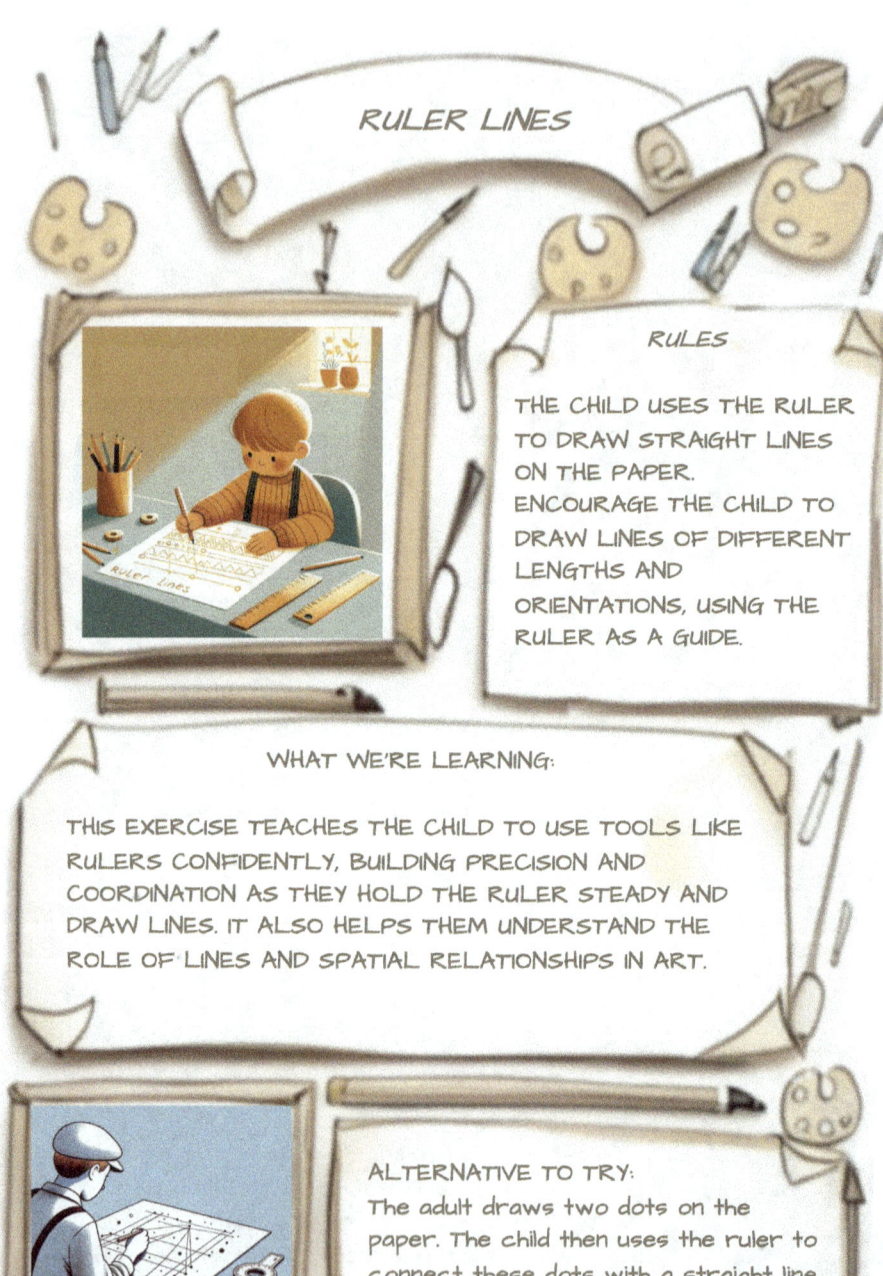

RULES

THE CHILD USES THE RULER TO DRAW STRAIGHT LINES ON THE PAPER. ENCOURAGE THE CHILD TO DRAW LINES OF DIFFERENT LENGTHS AND ORIENTATIONS, USING THE RULER AS A GUIDE.

WHAT WE'RE LEARNING:

THIS EXERCISE TEACHES THE CHILD TO USE TOOLS LIKE RULERS CONFIDENTLY, BUILDING PRECISION AND COORDINATION AS THEY HOLD THE RULER STEADY AND DRAW LINES. IT ALSO HELPS THEM UNDERSTAND THE ROLE OF LINES AND SPATIAL RELATIONSHIPS IN ART.

ALTERNATIVE TO TRY:
The adult draws two dots on the paper. The child then uses the ruler to connect these dots with a straight line, practicing precision and control.

STEP AND GUESS

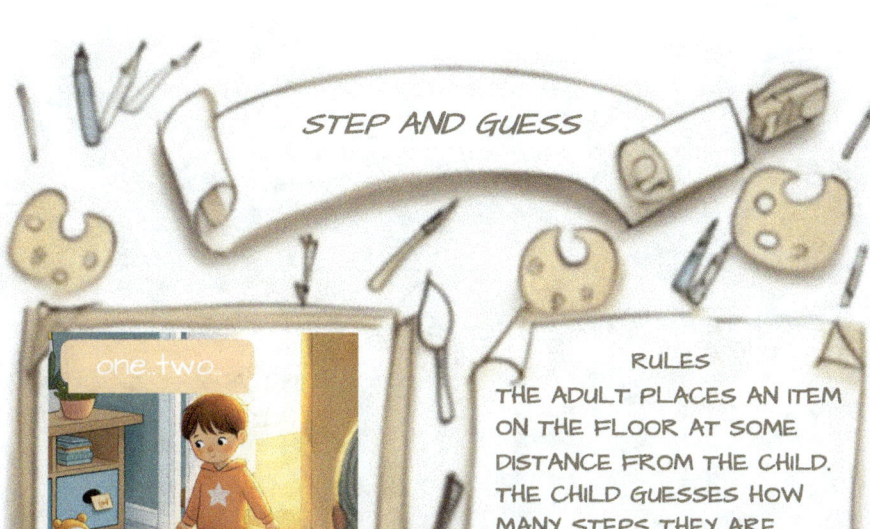

RULES
THE ADULT PLACES AN ITEM ON THE FLOOR AT SOME DISTANCE FROM THE CHILD. THE CHILD GUESSES HOW MANY STEPS THEY ARE AWAY FROM THE ITEM. THE CHILD THEN WALKS TO THE ITEM, COUNTING THE STEPS, TO SEE IF THEIR GUESS WAS CORRECT.

WHAT WE'RE LEARNING:

THIS GAME HELPS THE CHILD DEVELOP ESTIMATION SKILLS AND SPATIAL AWARENESS BY GUESSING DISTANCES. IT INTRODUCES BASIC MEASUREMENT CONCEPTS. SWITCHING ROLES ADDS PERSPECTIVE, HELPING THEM UNDERSTAND ESTIMATION FROM DIFFERENT VIEWPOINTS.

ALTERNATIVE TO TRY:
Switch roles where the adult guesses the number of steps to the item and the child places the item. This variation encourages mutual participation and understanding of distance estimation from different perspectives.

LINE SEEKERS

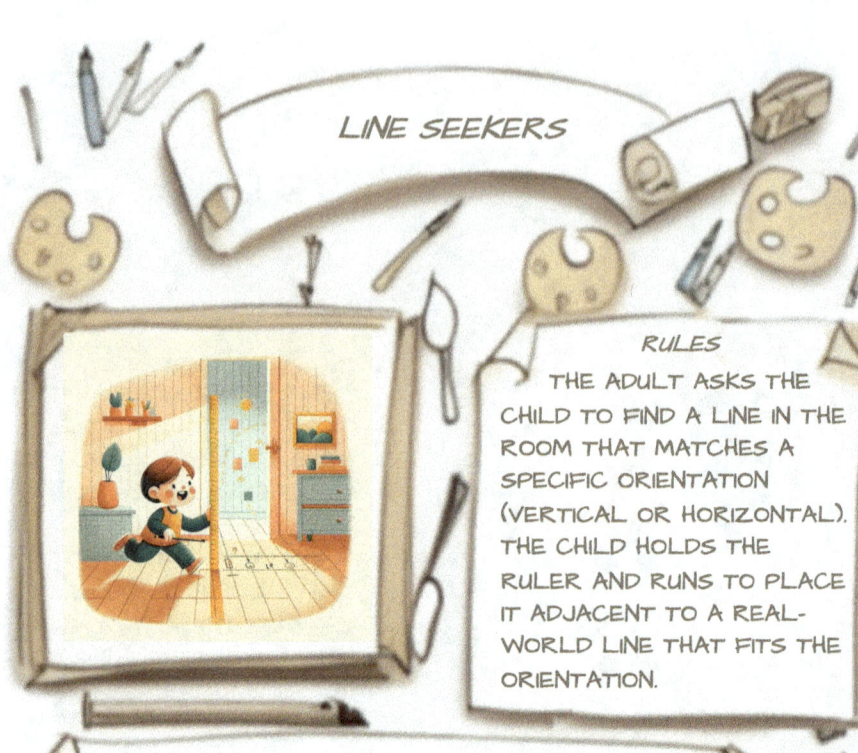

RULES
The adult asks the child to find a line in the room that matches a specific orientation (vertical or horizontal). The child holds the ruler and runs to place it adjacent to a real-world line that fits the orientation.

WHAT WE'RE LEARNING:
This game helps the child understand contours, straight edges, and borders, linking observed lines to physical movement, which reinforces learning. It emphasizes that drawing from life involves actively looking for and recognizing these lines.

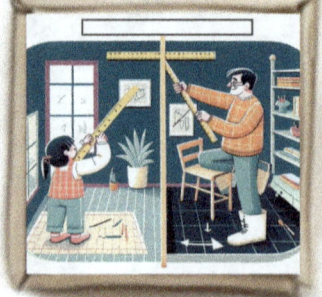

ALTERNATIVE TO TRY:
Invert the roles where the child asks the adult to find a specific line. This variation helps the child see how adults approach the same task, enhancing their understanding of observation and perspective.

ART APPRECIATION QUEST

RULES

The child and adult take turns flipping through an art book. Each person rates the artworks based on their personal preference, discussing what they like most about each piece.

WHAT WE'RE LEARNING:

This activity helps the child appreciate different art styles and see that artists explore and interpret real life in unique ways. It enhances their observation of elements like color and composition and encourages open communication about personal tastes while considering others' perspectives.

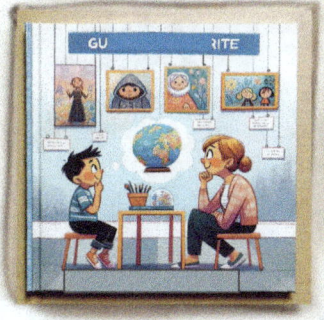

ALTERNATIVE TO TRY:

Each person tries to guess which artwork the other liked the most. This variation promotes understanding and empathy, as it requires considering the other person's perspective and taste in art.

MEMORY LINES

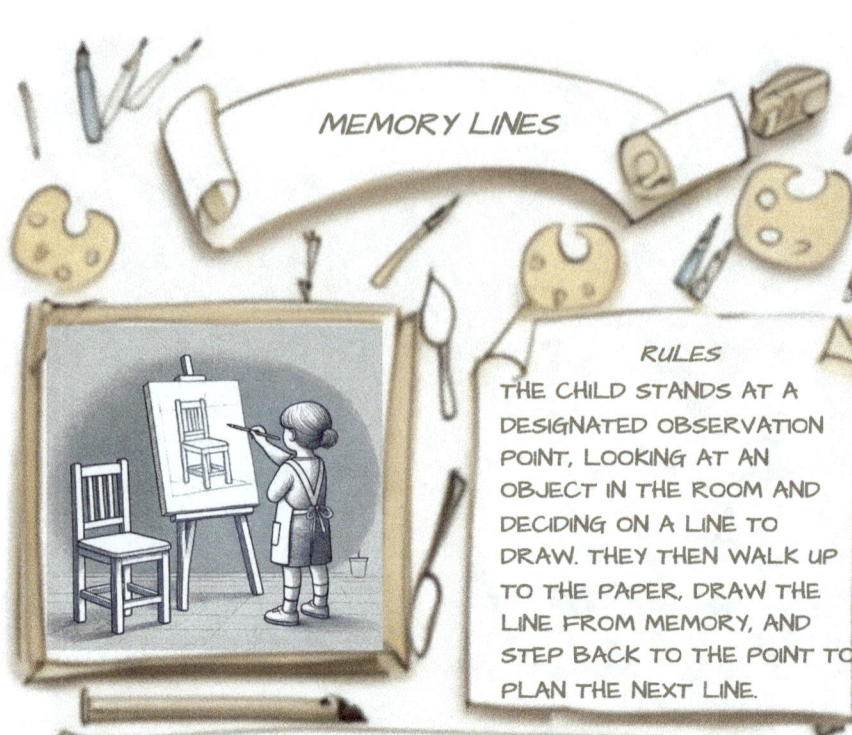

RULES
The child stands at a designated observation point, looking at an object in the room and deciding on a line to draw. They then walk up to the paper, draw the line from memory, and step back to the point to plan the next line.

WHAT WE'RE LEARNING:
This exercise strengthens visual memory, helping the child retain and recreate images- a key skill for large artworks. It improves observation and drawing skills by encouraging careful study of objects and translating them into lines and shapes.

ALTERNATIVE TO TRY:
Start with simple objects and gradually move to more complicated ones. This progression helps the child develop their memory and drawing skills incrementally.

DESCRIBE & DRAW

RULES

The child picks a toy and describes its shape, color, and features in detail with the adult's help. Using this description, the child then draws the toy, incorporating all the details they mentioned.

WHAT WE'RE LEARNING:

This exercise builds observation skills and vocabulary by encouraging the child to describe details closely. It shows how descriptions support drawing and develops creativity and attention to detail in both speaking and art.

ALTERNATIVE TO TRY:

Switch to different items for the child to describe and draw, such as household objects, nature elements, or other toys. This variation challenges the child to observe and describe a variety of objects.

NEGATIVE SHAPES

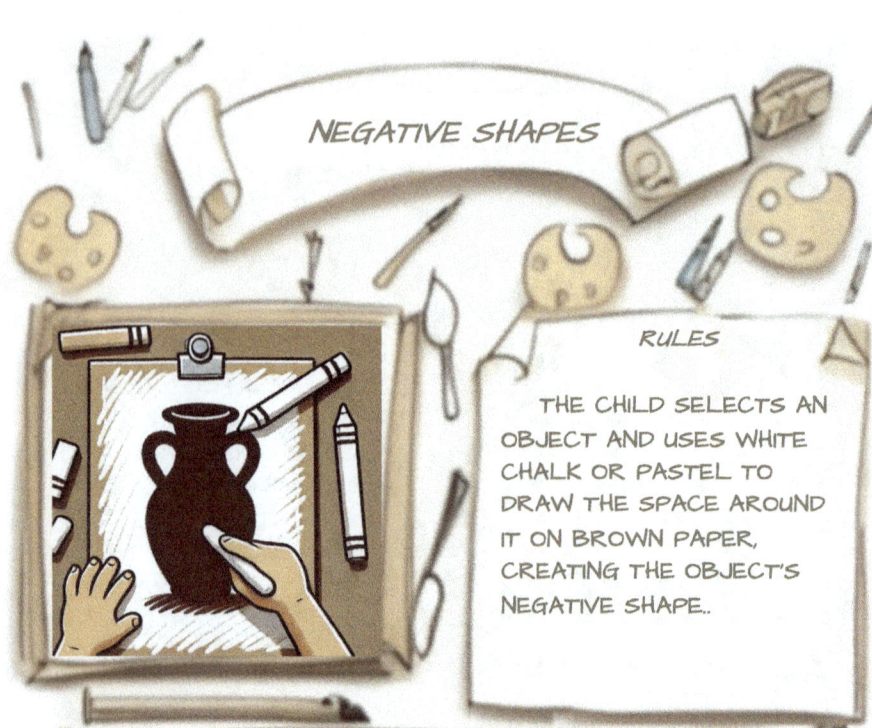

RULES

THE CHILD SELECTS AN OBJECT AND USES WHITE CHALK OR PASTEL TO DRAW THE SPACE AROUND IT ON BROWN PAPER, CREATING THE OBJECT'S NEGATIVE SHAPE..

WHAT WE'RE LEARNING:

THIS EXERCISE TEACHES THE CONCEPT OF NEGATIVE SPACE, SHOWING ITS IMPORTANCE IN COMPOSITION. IT ENCOURAGES THE CHILD TO OBSERVE THE SPACE AROUND OBJECTS, ENHANCING DRAWING SKILLS AND FOSTERING CREATIVITY THROUGH AN UNCONVENTIONAL APPROACH THAT HIGHLIGHTS THE ROLE OF BACKGROUND SPACE IN ART.

ALTERNATIVE TO TRY:

Have the child draw different objects using the same technique, helping them understand how various shapes and sizes affect the negative space in a drawing.

ELLIPSE MASTERY

RULES

The child starts by drawing ellipses on paper with an ellipse template. After some practice, they try drawing ellipses freehand, aiming to match the accuracy of the template.

WHAT WE'RE LEARNING:

This exercise develops precision in drawing, especially for ellipses and other shapes. It improves hand-eye coordination and helps the child understand geometric forms, which are essential in art and design.

ALTERNATIVE TO TRY:

Expand the exercise to include other geometric shapes using various tracing devices, such as circle templates or rulers for straight lines.

COMPOSITION SNAP

RULES
The child arranges some items on a chair to create a composition. The adult takes a photo, and they both rate its appeal. The child then adjusts one item at a time, with the adult photographing each new arrangement.

WHAT WE'RE LEARNING:
This exercise teaches the child how to arrange items in a visually pleasing way, a key skill for still life art. It encourages observation and creativity as they adjust elements to improve the composition. Photography helps them document and reflect on each change, seeing the impact of their adjustments.

ALTERNATIVE TO TRY:
Increase the number of objects in the composition. This variation challenges the child to consider more elements and their interactions, enhancing their understanding of balance and harmony in a composition.

COLOR SPECTRUM QUEST

RULES

THE ADULT ASKS THE CHILD TO FIND RED ITEMS IN THE ROOM. TOGETHER, THEY EXAMINE THE DIFFERENT SHADES OF RED, SORTING THE ITEMS BY HUE, SATURATION, AND VALUE, AND DISCUSSING HOW EACH SHADE VARIES.

WHAT WE'RE LEARNING:

THIS GAME TEACHES THE CHILD ABOUT COLOR PROPERTIES LIKE HUE, SATURATION, AND VALUE, ENHANCING THEIR ABILITY TO NOTICE AND CATEGORIZE SUBTLE COLOR DIFFERENCES.

ALTERNATIVE TO TRY:

For advanced users, take pictures of the collected items and use Photoshop or a similar program to analyze the actual color values. Compare these values to their initial guesses.

DIGITAL CANVAS CHALLENGE

RULES
THE CHILD AND ADULT CREATE A DRAWING USING A DIGITAL TOOL, THEN RECREATE IT ON PAPER. THEY COMPARE THE TWO DRAWINGS TO EXPLORE DIFFERENCES IN EXPERIENCE AND HOW SCREEN LIGHT DIFFERS FROM PAPER'S REFLECTED LIGHT.

WHAT WE'RE LEARNING:

THIS EXERCISE TEACHES THE CHILD THE DIFFERENCES BETWEEN DIGITAL AND PAPER DRAWING, INCLUDING HOW LIGHT AFFECTS EACH. IT ENCOURAGES ADAPTABILITY WITH VARIOUS TOOLS AND MEDIUMS AND ENHANCES OBSERVATION SKILLS BY SHOWING HOW THE SAME SUBJECT CAN LOOK DIFFERENT IN EACH FORMAT.

ALTERNATIVE TO TRY:
Explore various digital tools and compare them with different traditional mediums like watercolor, charcoal, or crayons to see how each medium influences the drawing experience and outcome.

OUTDOOR ART EXPLORER

RULES

THE CHILD TAKES A SKETCHBOOK OUTDOORS TO A PARK OR STREET, SELECTS A SCENE OR OBJECT, AND DRAWS IT FROM LIFE, FOCUSING ON CAPTURING THE SURROUNDINGS AS ACCURATELY AS POSSIBLE.

WHAT WE'RE LEARNING:

THIS ACTIVITY IMPROVES OBSERVATION SKILLS BY HELPING THE CHILD CAPTURE NATURAL LIGHT, SHADOWS, AND COLORS. IT BUILDS CONFIDENCE BY CREATING ART IN PUBLIC AND FOSTERS A CONNECTION WITH NATURE.

ALTERNATIVE TO TRY:

Canvas Painting in Public For the more adventurous, the child sets up an easel and paints on a canvas outdoors.

WINDOW TRACE WONDERS

RULES

The adult tapes transparent paper to a window. The child looks through the paper at the landscape outside and traces the scene onto it, focusing on capturing real-life lines and shapes.

WHAT WE'RE LEARNING:

This activity helps the child practice drawing from life by translating real scenes onto paper. It enhances observation and coordination skills, and teaches proportions and perspective.

ALTERNATIVE TO TRY:

Place the transparent paper on a mirror. The child then creates a self-portrait by tracing their reflection. This alternative enhances the child's understanding of proportions and self-portrait.

SHADES AND HUES EXPLORER

RULES

PLACE SHADED GRAY STRIPS ON DIFFERENT GRAY BACKGROUNDS. OBSERVE AND DISCUSS HOW THE GRAY STRIP'S APPEARANCE CHANGES BASED ON THE SURROUNDING BACKGROUND.

WHAT WE'RE LEARNING:

THIS ACTIVITY TEACHES SIMULTANEOUS CONTRAST, SHOWING HOW COLORS OR SHADES APPEAR DIFFERENTLY IN VARYING CONTEXTS. IT BUILDS COLOR AWARENESS AND SHARPENS OBSERVATIONAL SKILLS, HELPING THE CHILD NOTICE AND DESCRIBE SUBTLE DIFFERENCES IN COLORS AND SHADES.

ALTERNATIVE TO TRY:

Use colored strips and background papers to explore how the perception of a color changes based on its surrounding hues.

ANGLE ADVENTURE

RULES

The adult asks the child to find a 90-degree angle in the room, like a table corner or where walls meet. Then, they look for a 45-degree angle, such as in a partially open door. Room.

WHAT WE'RE LEARNING:

This game builds familiarity with basic angles, improving spatial awareness and estimation skills. Recognizing angles in everyday life also boosts confidence, helping the child overcome drawing fears and translate these concepts onto paper.

ALTERNATIVE TO TRY:

For a more advanced version, use a degree measurement tool. The child is asked to guess the degree of angles found in the room and then use the tool to measure and compare the estimates with the actual measurements.

INFINITE HALVES

RULES

THE CHILD BEGINS WITH A LARGE PIECE OF PAPER AND KEEPS CUTTING EACH PIECE IN HALF UNTIL IT'S TOO SMALL TO CUT FURTHER.

WHAT WE'RE LEARNING:

THIS GAME TEACHES THE CHILD THAT, WHILE SOMETHING CAN BE DIVIDED INFINITELY IN THEORY, THERE'S A PRACTICAL LIMIT. IT IMPROVES SPATIAL AWARENESS AND RELATES TO ART BY SHOWING HOW ARTISTS CHOOSE DETAIL LEVELS THAT CAN BE SEEN AND REPRESENTED.

ALTERNATIVE TO TRY:

Instead of cutting, the child folds the paper in half repeatedly. The challenge is to see how quickly it becomes impossible to fold it further.

PARALLEL PURSUIT

RULES

THE ADULT ASKS THE CHILD TO FIND TWO PARALLEL LINES IN THE ROOM, SUCH AS THE EDGES OF CLOSETS, BOOKSHELVES, OR DOOR FRAMES.

WHAT WE'RE LEARNING:

THIS GAME TEACHES THE CHILD TO SPOT AND UNDERSTAND PARALLEL LINES IN EVERYDAY OBJECTS, LIKE CLOSET EDGES OR DOOR FRAMES. IT CONNECTS THE CONCEPT OF PARALLEL LINES IN DRAWING TO REAL-LIFE EXAMPLES, HELPING THE CHILD RECOGNIZE THESE LINES IN BOTH ART AND THE PHYSICAL WORLD.

ALTERNATIVE TO TRY:

Look for parallel lines outside the window, such as in building structures, roads, or rooftops. The adult then asks the child to guess where they think these lines would meet, introducing the concept of vanishing points in perspective.

GRID MASTERPIECE

RULES

Draw a grid over a printed master drawing, then draw the same grid on blank paper. The child, with the adult's help, replicates the drawing by focusing on one grid square at a time.

WHAT WE'RE LEARNING:

This activity teaches the grid method, helping the child break down complex images into manageable parts for accurate drawing. It introduces traditional art techniques and improves observation and precision, enhancing drawing skills and attention to detail.

ALTERNATIVE TO TRY:

Build a wire grid device as old masters might have used for real-life drawing. Use this device to assist in replicating a drawing from real life or another artwork, focusing on precision and detail.

ANATOMY EXPLORER

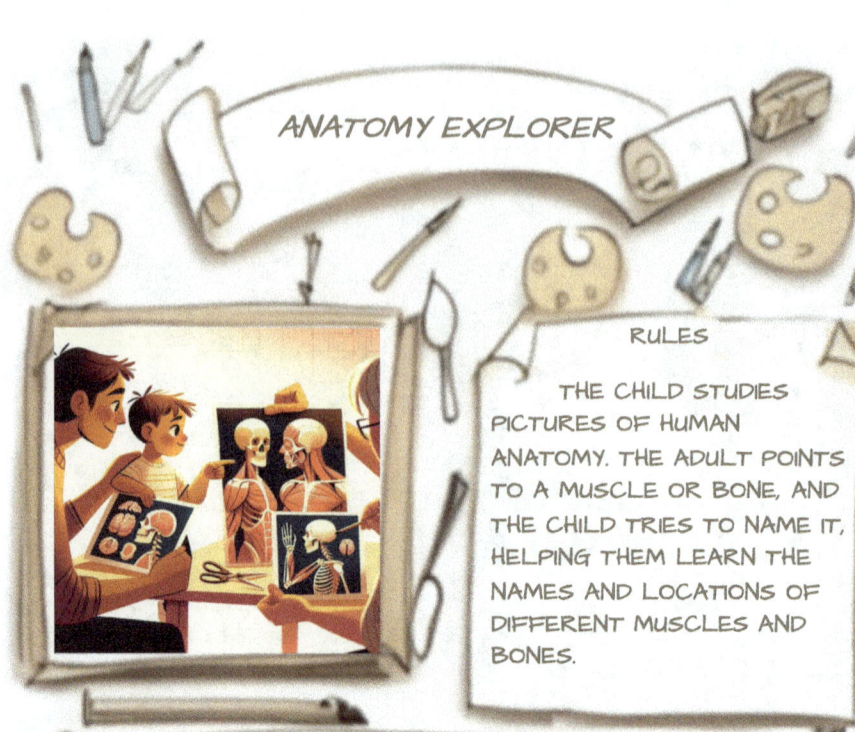

RULES

The child studies pictures of human anatomy. The adult points to a muscle or bone, and the child tries to name it, helping them learn the names and locations of different muscles and bones.

WHAT WE'RE LEARNING:

This game builds a basic understanding of human anatomy, essential for drawing human figures and it improves observation skills.

ALTERNATIVE TO TRY:

The adult asks the child where a particular muscle is attached on the body. The child then points to the corresponding locations on their own body, identifying attachment points of different muscles.

DOT CREATIVITY

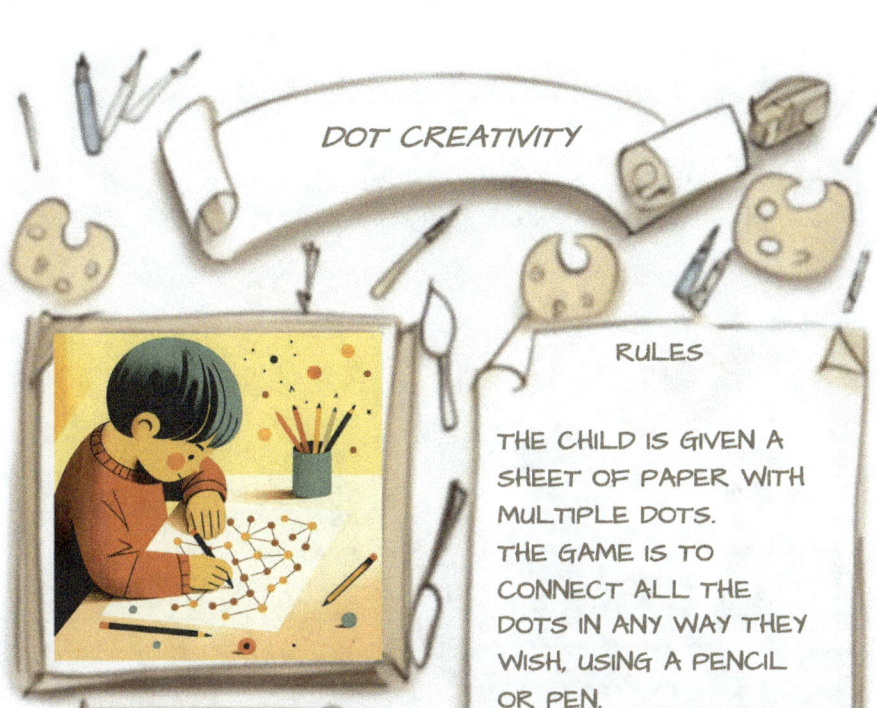

RULES

THE CHILD IS GIVEN A SHEET OF PAPER WITH MULTIPLE DOTS. THE GAME IS TO CONNECT ALL THE DOTS IN ANY WAY THEY WISH, USING A PENCIL OR PEN.

WHAT WE'RE LEARNING:

THIS ACTIVITY IMPROVES HAND-EYE COORDINATION AND FINE MOTOR SKILLS. IT ENCOURAGES CREATIVITY IN CREATING PATTERNS AND SHAPES AND INTRODUCES THE CHILD TO DIFFERENT TEXTURES AND EFFECTS WITH VARIOUS TOOLS.

ALTERNATIVE TO TRY:

Instead of a pencil or pen, use various artistic tools like brushes, big markers, and pastels to connect the dots. This variation encourages exploration of different textures and effects in artwork.

YOUNG MASTER PAINTER

RULES

THE CHILD DRESSES UP LIKE A PROFESSIONAL PAINTER AND SETS UP A REAL-LIFE PAINTING STATION.
THEY CHOOSE A STILL LIFE OBJECT TO PAINT.

WHAT WE'RE LEARNING:

THIS ACTIVITY INTRODUCES THE CHILD TO PROFESSIONAL PAINTING SKILLS, INCLUDING SETUP, COMPOSITION, AND TECHNIQUE. IT IMPROVES UNDERSTANDING OF FORM AND 3D SPACE AND BUILDS CONFIDENCE IN THEIR ABILITY TO PAINT FROM REAL LIFE.

ALTERNATIVE TO TRY:

Instead of a still life, the child attempts to paint a portrait of an adult.
This activity involves capturing the adult's likeness and expressions, offering a different challenge.

3D OBJECT EXPLORER

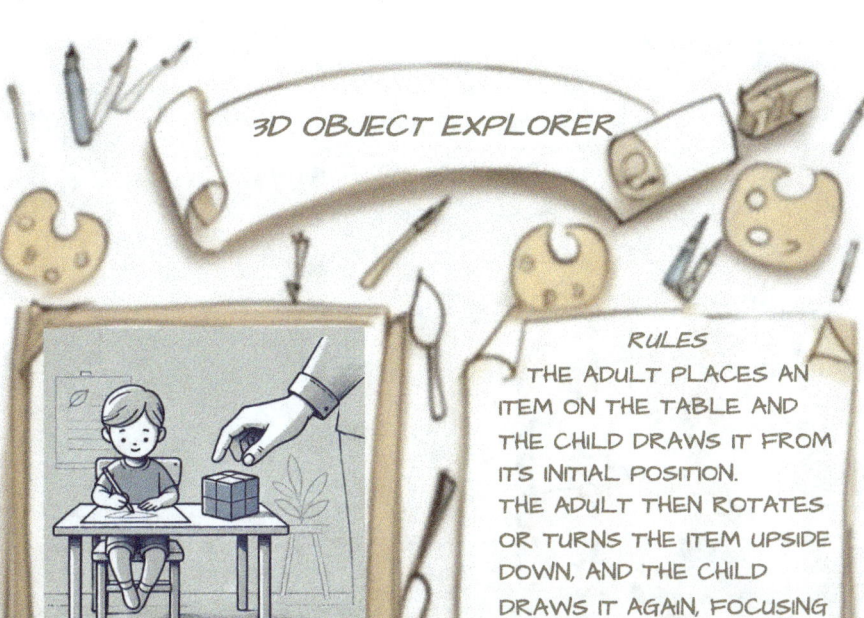

RULES

The adult places an item on the table and the child draws it from its initial position. The adult then rotates or turns the item upside down, and the child draws it again, focusing on capturing the changed perspective.

WHAT WE'RE LEARNING:

This activity helps the child understand and draw solid, 3D forms. It improves spatial awareness and perspective and, with more complex items, develops advanced drawing skills for capturing details and shapes.

ALTERNATIVE TO TRY:

Use more complex items, such as mechanical toys or multifaceted sculptures, to increase the challenge of capturing their form and structure from various angles.

BRUSH POINT PRECISION

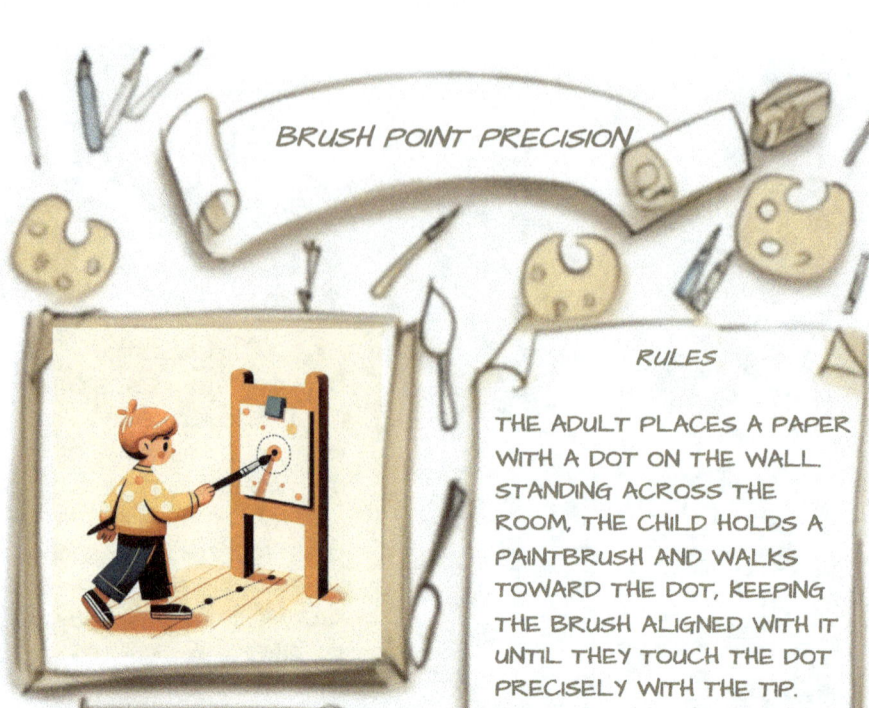

RULES

THE ADULT PLACES A PAPER WITH A DOT ON THE WALL. STANDING ACROSS THE ROOM, THE CHILD HOLDS A PAINTBRUSH AND WALKS TOWARD THE DOT, KEEPING THE BRUSH ALIGNED WITH IT UNTIL THEY TOUCH THE DOT PRECISELY WITH THE TIP.

WHAT WE'RE LEARNING:

THIS ACTIVITY IMPROVES COORDINATION AND FOCUS ON A DISTANT POINT. IT BUILDS SPATIAL AWARENESS BY TEACHING THE CHILD TO STEP BACK FOR A BROADER VIEW AND ENHANCES MEMORY AND PRECISION, KEY SKILLS IN PAINTING AND DRAWING.

ALTERNATIVE TO TRY:

Keep a score of how many times the child successfully aligns the brush with the dot. This adds a competitive and fun element to the game.

LINE DISCOVERY

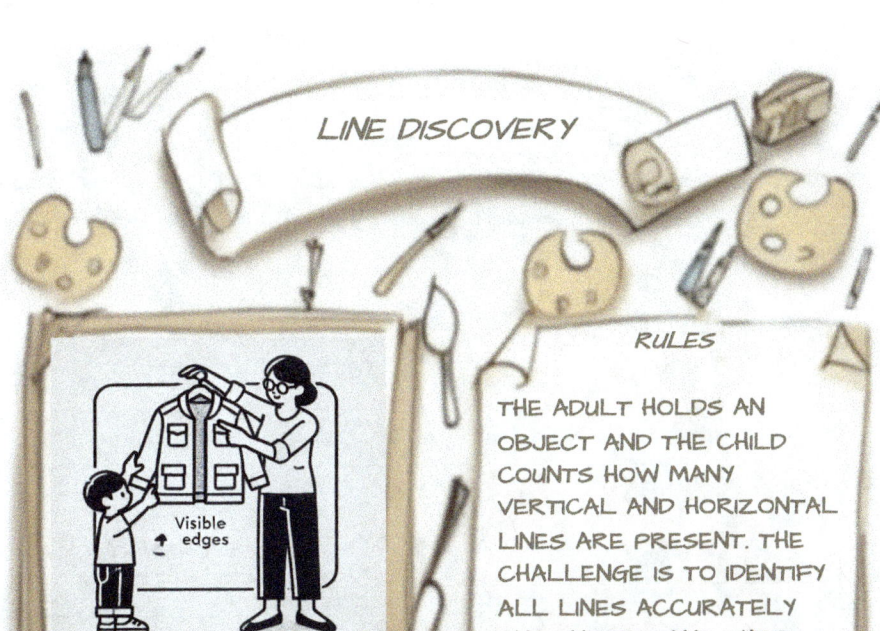

RULES

THE ADULT HOLDS AN OBJECT AND THE CHILD COUNTS HOW MANY VERTICAL AND HORIZONTAL LINES ARE PRESENT. THE CHALLENGE IS TO IDENTIFY ALL LINES ACCURATELY AND UNDERSTAND THEIR ORIENTATION.

WHAT WE'RE LEARNING:

THIS GAME IMPROVES THE CHILD'S ABILITY TO SEE AND IDENTIFY LINES IN REAL OBJECTS, TEACHES THEM ABOUT GEOMETRY AND STRUCTURE, AND ENCOURAGES INTERACTIVE LEARNING BY FOSTERING OBSERVATION AND ATTENTION TO DETAIL.

ALTERNATIVE TO TRY:

The child holds the item while the adult counts the lines. This variation encourages interaction and learning from different perspectives.

SHAPE SEEKERS

RULES

THE CHILD DRAWS A BASIC SHAPE (E.G., TRIANGLE, SQUARE) ON PAPER. THE ADULT THEN LOOKS FOR AT LEAST THREE OBJECTS IN THE ROOM THAT MATCH THE DRAWN SHAPE.

WHAT WE'RE LEARNING:

THIS ACTIVITY TEACHES THE CHILD TO RECOGNIZE BASIC SHAPES IN REAL OBJECTS, IMPROVING OBSERVATION AND VISUAL PERCEPTION. IT MAKES LEARNING SHAPES INTERACTIVE AND FUN, FOSTERING CURIOSITY AND CREATIVITY.

ALTERNATIVE TO TRY:

The adult draws the shape, and the child searches for matching objects. This variation encourages both observation and participation from the child.

CLEAR VIEW TRACING

RULES

THE CHILD USES A TRANSPARENT ACRYLIC GLASS TO TRACE OBJECTS OR SCENES FROM REAL LIFE. THEY PLACE THE GLASS BETWEEN THEMSELVES AND THE OBJECT, CAREFULLY TRACING ITS OUTLINE AND DETAILS.

WHAT WE'RE LEARNING:

THIS ACTIVITY IMPROVES THE CHILD'S OBSERVATION AND DRAWING ACCURACY, HELPS THEM UNDERSTAND PROPORTIONS AND SHAPES, AND BOOSTS CONFIDENCE IN DRAWING FROM LIFE.

ALTERNATIVE TO TRY:

Instead of objects, the child uses the transparent glass to trace the features of a person, focusing on capturing expressions and facial details.

SHADOW FORM EXPLORER

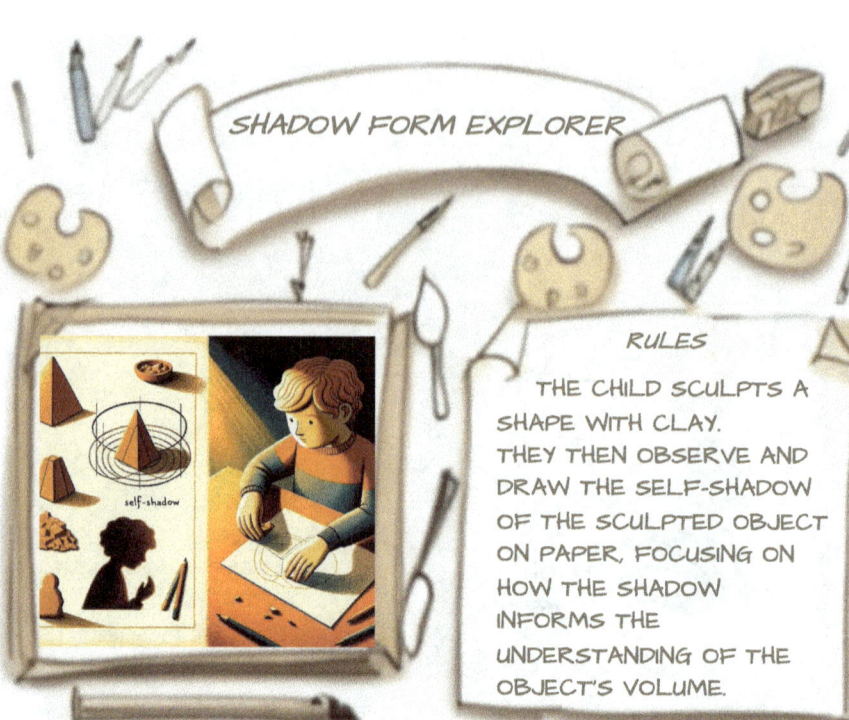

RULES

THE CHILD SCULPTS A SHAPE WITH CLAY. THEY THEN OBSERVE AND DRAW THE SELF-SHADOW OF THE SCULPTED OBJECT ON PAPER, FOCUSING ON HOW THE SHADOW INFORMS THE UNDERSTANDING OF THE OBJECT'S VOLUME.

WHAT WE'RE LEARNING:

THIS ACTIVITY TEACHES THE CHILD HOW SHADOWS REVEAL AN OBJECT'S VOLUME, ENHANCING THEIR ABILITY TO OBSERVE AND DRAW SHADOWS FOR REALISTIC EFFECTS. IT ALSO INTRODUCES THE CONCEPT OF THE TERMINATOR LINE, WHERE LIGHT SHIFTS TO SHADOW ON A FORM.

ALTERNATIVE TO TRY:

The adult asks the child to identify the line where the light meets the shadow (the terminator line) on the sculpted object. The child points to this line, enhancing their understanding of how light and shadow define form.

DOUGH LINE ART

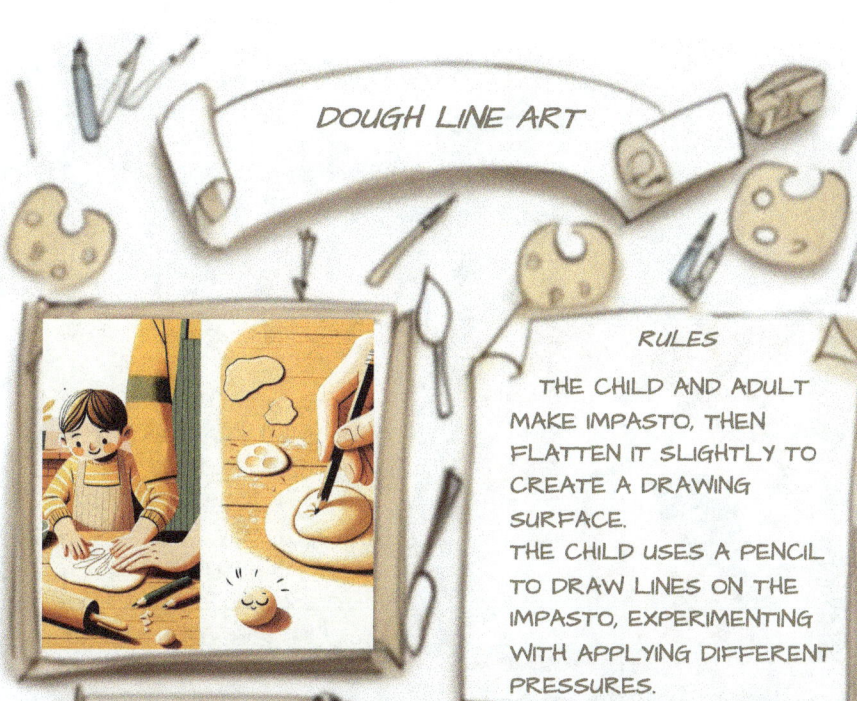

RULES

The child and adult make impasto, then flatten it slightly to create a drawing surface.
The child uses a pencil to draw lines on the impasto, experimenting with applying different pressures.

WHAT WE'RE LEARNING:

This activity improves the child's control and precision with a drawing tool, builds fine motor skills, and teaches them about texture and depth in art.

ALTERNATIVE TO TRY:

The adult makes an incision in the impasto, and the child attempts to match the same depth with another line, focusing on precision and control.

EXTENDED GRIP ART

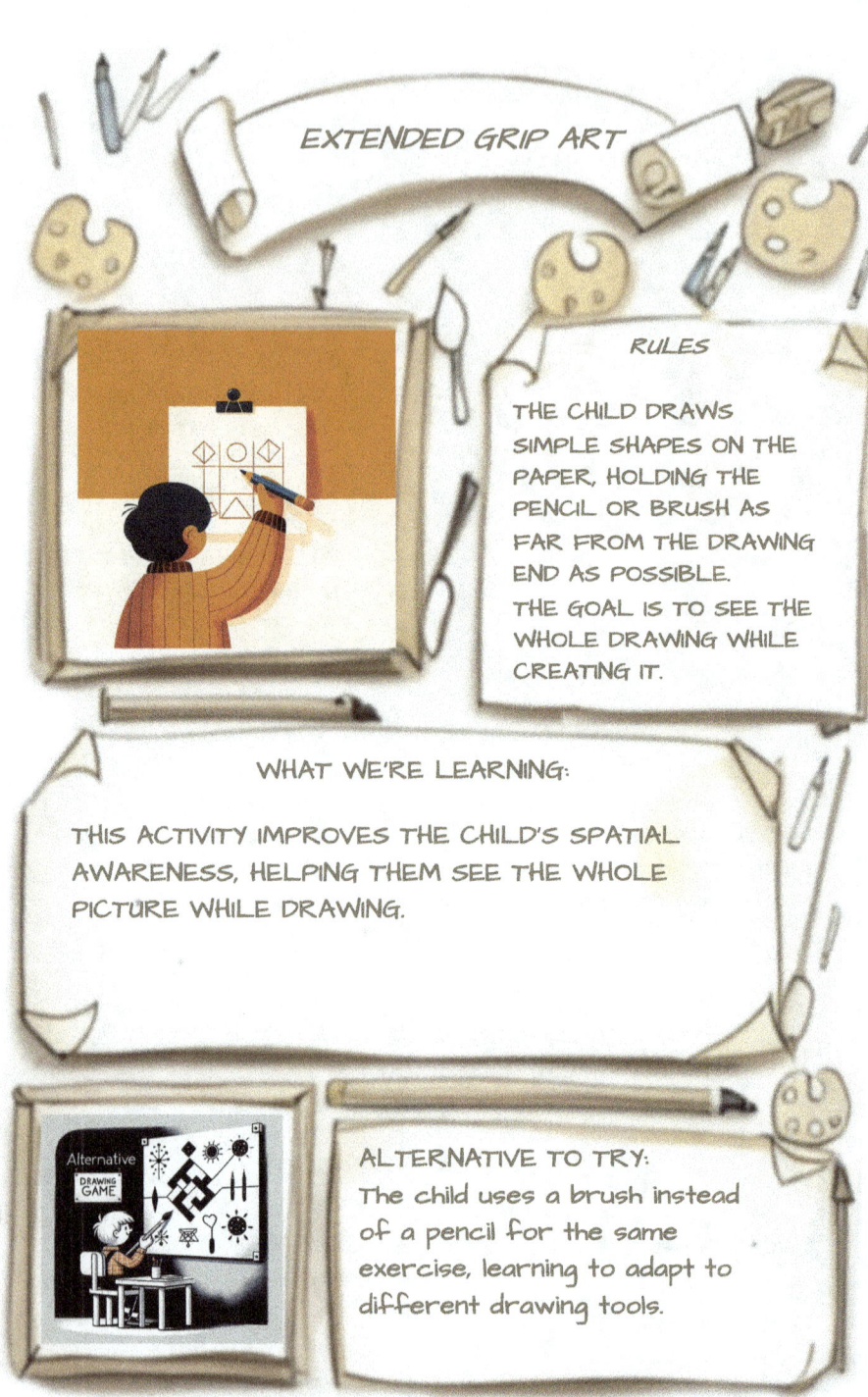

RULES

THE CHILD DRAWS SIMPLE SHAPES ON THE PAPER, HOLDING THE PENCIL OR BRUSH AS FAR FROM THE DRAWING END AS POSSIBLE. THE GOAL IS TO SEE THE WHOLE DRAWING WHILE CREATING IT.

WHAT WE'RE LEARNING:

THIS ACTIVITY IMPROVES THE CHILD'S SPATIAL AWARENESS, HELPING THEM SEE THE WHOLE PICTURE WHILE DRAWING.

ALTERNATIVE TO TRY:

The child uses a brush instead of a pencil for the same exercise, learning to adapt to different drawing tools.

FRAME THE VIEW

RULES

THE ADULT HOLDS A CARDBOARD FRAME AND MOVES IT AROUND THE ROOM.
THE CHILD OBSERVES THROUGH THE FRAME AND DIRECTS THE ADULT TO STOP WHEN THEY SEE A PLEASING COMPOSITION.

WHAT WE'RE LEARNING:

THIS ACTIVITY TEACHES THE CHILD TO EXPLORE AND ASSESS THEIR SURROUNDINGS FOR PLEASING COMPOSITIONS. IT IMPROVES THEIR UNDERSTANDING OF FRAMING AND COMPOSITION.

ALTERNATIVE TO TRY:

Instead of a cardboard frame, the child uses a smartphone to find and capture good compositions, focusing on framing and composition through the camera lens.

A STRING OF WOOL

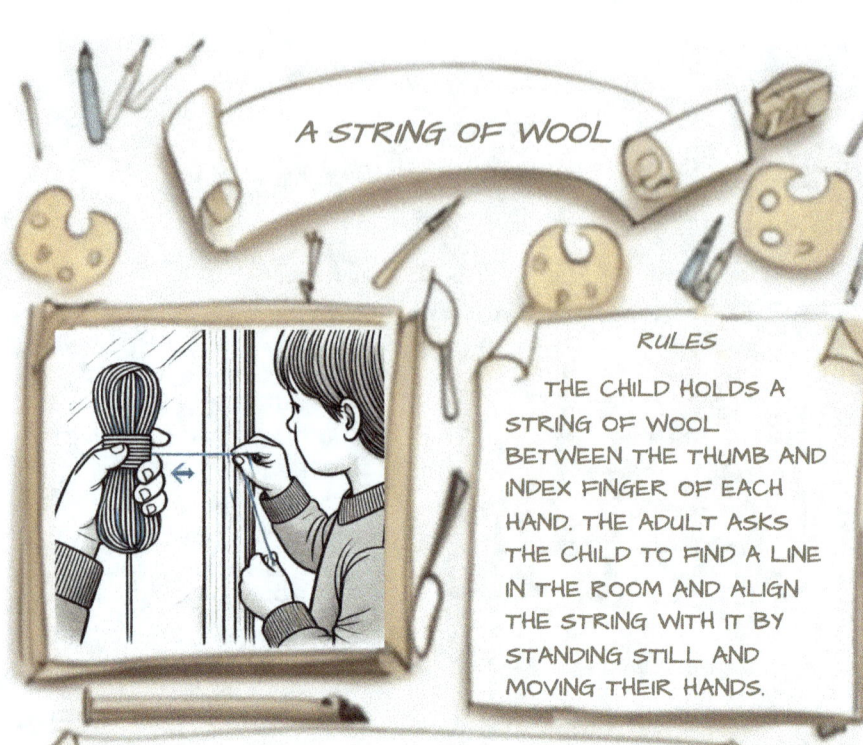

RULES

The child holds a string of wool between the thumb and index finger of each hand. The adult asks the child to find a line in the room and align the string with it by standing still and moving their hands.

WHAT WE'RE LEARNING:

This game teaches the child to understand lines and angles by observing them in real life. It builds spatial awareness and enhances observation skills by helping them simplify complex forms into basic lines and angles.

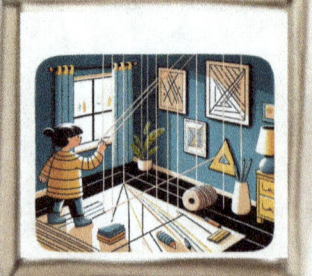

ALTERNATIVE TO TRY:

The child uses the string to find and align with various lines in the room, including diagonal lines, enhancing their understanding of spatial relationships and line perception.

SHADOW PLAY

RULES

On a sunny day, go outside with a piece of paper. The child draws an outdoor object, focusing on its cast shadow.
The adult then places the paper where the cast shadow is projected, helping the child to draw the shadow accurately.

WHAT WE'RE LEARNING:

This activity teaches the child about cast shadows, color contrast, and observing shadows in a natural setting, improving their observational skills and artistic understanding.

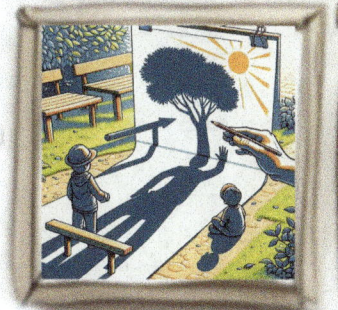

ALTERNATIVE TO TRY:

The child holds the paper, and the adult draws the cast shadow.

COLOR REFLECTION

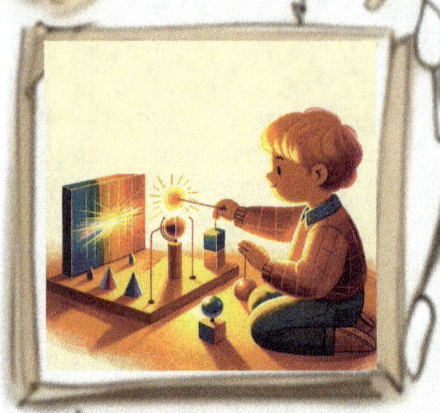

RULES
Place two colorful, shiny objects close together on a white surface. Shine a flashlight on one object and have the child observe how the color reflects onto the other, creating a subtle new color where they're close.

WHAT WE'RE LEARNING:

When two colored objects are placed close to each other, light reflecting off one object can cast a faint tint onto the other. This effect is more noticeable when one or both surfaces are highly reflective or glossy, and it can result in subtle color shifts.

ALTERNATIVE TO TRY:
The adult performs the exercise while the child observes and guesses the color mix, learning about light reflection in painting.

SPIRAL PRECISION

RULES

THE CHILD DRAWS A SPIRAL ON THE PAPER, TRYING TO MAKE IT AS LONG AND CONTINUOUS AS POSSIBLE..

WHAT WE'RE LEARNING:

THE GAME TEACHES THE CHILD GREATER CONTROL OVER PENCIL MOVEMENTS AND PRESSURE.
THE OBJECTIVE IS TO DEVELOP CONTROL AND PRECISION IN PENCIL HANDLING.

ALTERNATIVE TO TRY:
After completing the first spiral, the child draws a second spiral in the white spaces left from the previous one, focusing on precision and control in tight spaces.

CIRCUIT TRACE RACE

RULES

THE ADULT DRAWS A CAR RACING CIRCUIT ON A PIECE OF PAPER. THE CHILD TRACES A LINE IN THE CIRCUIT FROM START TO FINISH WITHOUT TOUCHING ANY EDGES.

WHAT WE'RE LEARNING:

THIS GAME HELPS THE CHILD IMPROVE SKILLS IN HOLDING THE PENCIL PROPERLY, ENSURING CLEAR VISIBILITY WHILE DRAWING.

ALTERNATIVE TO TRY:

Both the child and adult race together in the same circuit, each tracing their own line and trying not to touch the edges.

SHADOW ARTISTRY

RULES

THE ADULT PLACES AN OBJECT ON A TABLE AND USES THE SMARTPHONE'S LIGHT TO CAST A SHADOW. THE CHILD THEN DRAWS ONLY THE CAST SHADOW OF THE OBJECT AS PROJECTED ON THE TABLE.

WHAT WE'RE LEARNING:

THE GAME TEACHES THE CHILD ABOUT LIGHT PROJECTIONS AND THE PRINCIPLES OF CAST SHADOWS IN ART. ENCOURAGES THE CHILD TO EXPLORE HOW LIGHT AFFECTS THE PERCEPTION AND REPRESENTATION OF SHADOWS, A CRUCIAL ELEMENT IN REALISTIC DRAWING AND PAINTING.

ALTERNATIVE TO TRY:

The adult moves the light source to create different cast shadows, and the child redraws these shadows, adapting to their new forms and angles.

OVERLAP EXPLORER

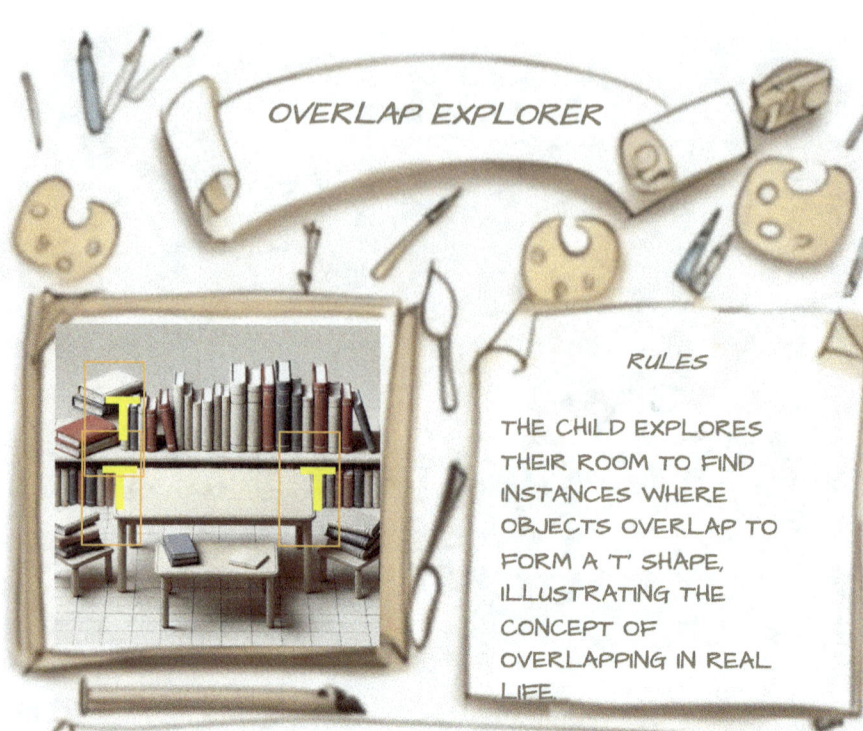

RULES

THE CHILD EXPLORES THEIR ROOM TO FIND INSTANCES WHERE OBJECTS OVERLAP TO FORM A 'T' SHAPE, ILLUSTRATING THE CONCEPT OF OVERLAPPING IN REAL LIFE.

WHAT WE'RE LEARNING:

THIS EXERCISE TEACHES THE CHILD ABOUT OVERLAPPING TO CREATE DEPTH AND PERSPECTIVE IN ART, IMPROVES SPATIAL AWARENESS, AND STRENGTHENS OBSERVATIONAL SKILLS FOR UNDERSTANDING REAL-WORLD SPATIAL RELATIONSHIPS.

ALTERNATIVE TO TRY:

The child or adult creates overlap situations using a piece of paper and a ruler, placing the ruler beneath the paper to demonstrate the 'T' shape formation.

EMOTION PORTRAYAL

RULES

THE ADULT MAKES A FACE EXPRESSING A SPECIFIC EMOTION.
THE CHILD OBSERVES AND DRAWS THE ADULT'S FACIAL EXPRESSION, CAPTURING THE EMOTION IN THEIR PORTRAIT.

WHAT WE'RE LEARNING:

THIS ACTIVITY HELPS THE CHILD RECOGNIZE AND DRAW FACIAL EXPRESSIONS, IMPROVES OBSERVATION SKILLS, AND TEACHES THE IMPORTANCE OF CAPTURING EMOTIONS IN ART.

ALTERNATIVE TO TRY:
The child makes a face expressing an emotion, and the adult draws the child's portrait, focusing on capturing the emotional expression.

NATURE'S PATTERNS

RULES

THE CHILD DRAWS A VASE OF FLOWERS, PAYING ATTENTION TO THE VARIANCE OF LINES IN THE FLOWERS AND LEAVES. THE GOAL IS TO CATCH AS MUCH OF THE VARIOUS CHANGES IN PATTERN AND DIRECTION OF EACH EDGE.

WHAT WE'RE LEARNING:

THIS ACTIVITY HELPS THE CHILD APPRECIATE NATURE'S PATTERNS, IMPROVES THEIR ABILITY TO OBSERVE DETAILS, AND TEACHES HOW OVERLAPPING CREATES DEPTH IN ART.

ALTERNATIVE TO TRY:

Instead of flowers, the child draws a leafless tree in winter, focusing on the complexity of its branches.

GRAND SCALE PORTRAITS

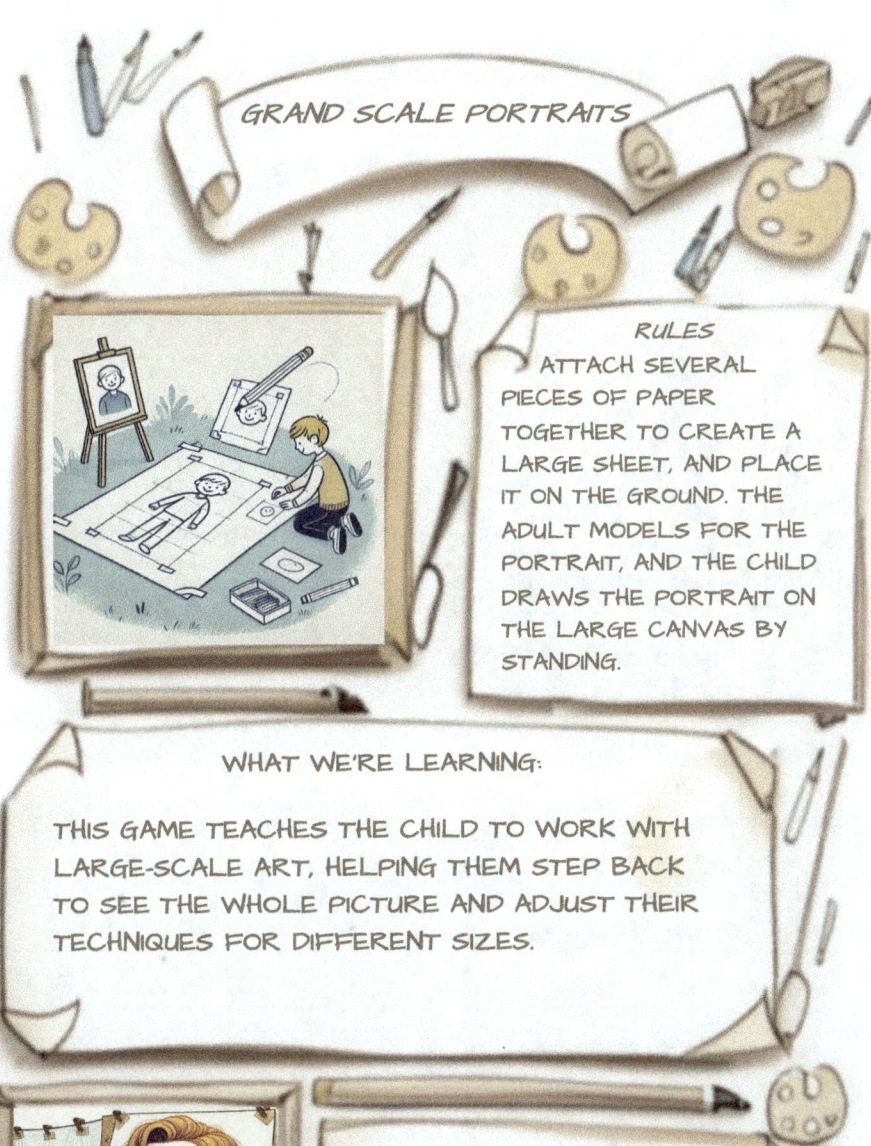

RULES
Attach several pieces of paper together to create a large sheet, and place it on the ground. The adult models for the portrait, and the child draws the portrait on the large canvas by standing.

WHAT WE'RE LEARNING:

This game teaches the child to work with large-scale art, helping them step back to see the whole picture and adjust their techniques for different sizes.

ALTERNATIVE TO TRY:
Instead of a pencil, the child uses a brush and paint to create the portrait, focusing on expressive strokes and color use.

CREATIVE COMPOSITION

RULES

THE ADULT ARRANGES OBJECTS IN A UNIQUE, IMPOSSIBLE COMPOSITION. THE CHILD OBSERVES AND DRAWS THE SETUP, FOCUSING ON CAPTURING THE CREATIVE ARRANGEMENT.

WHAT WE'RE LEARNING:

THIS GAME BOOSTS THE CHILD'S CREATIVITY, IMPROVES OBSERVATIONAL DRAWING SKILLS, AND TEACHES THEM ABOUT ARRANGING OBJECTS TO CREATE IMAGINATIVE SCENES.

ALTERNATIVE TO TRY:

The child creates their own imaginative setup with objects, and the adult draws the composition, capturing the child's inventiveness.

COLORFUL PAPER CREATIONS

RULES

THE CHILD DRAWS A REAL OBJECT PLACED ON A TABLE IN FRONT OF THEM, OR A LANDSCAPE, ON COLORED PAPER USING DIFFERENT COLORED PENCILS.

WHAT WE'RE LEARNING:

THIS GAME TEACHES THE CHILD ABOUT COLOR CONTRAST AND THE EFFECT OF USING DIFFERENT MEDIUMS ON COLORED PAPER.

ALTERNATIVE TO TRY:
Instead of an object, the child draws a landscape, focusing on how the landscape's colors interact with the paper's color.

BOTTLE SHAPES AND CURVES

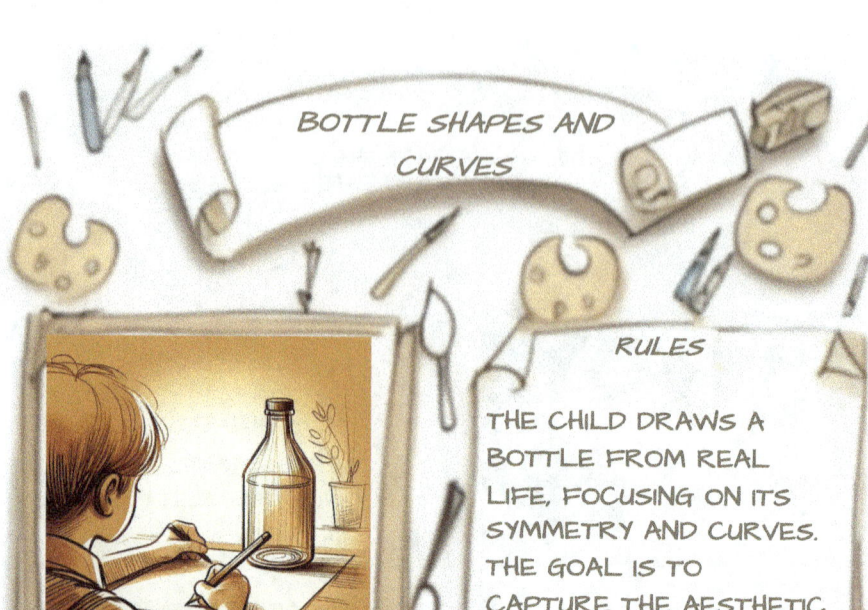

RULES

THE CHILD DRAWS A BOTTLE FROM REAL LIFE, FOCUSING ON ITS SYMMETRY AND CURVES. THE GOAL IS TO CAPTURE THE AESTHETIC FLOW AND COMPLEX SHAPES OF THE BOTTLE.

WHAT WE'RE LEARNING:

THIS EXERCISE TEACHES THE CHILD ABOUT DRAWING SYMMETRY AND AESTHETICALLY PLEASING CURVES. IT ENHANCES THE CHILD'S ABILITY TO OBSERVE AND DEPICT COMPLEX SHAPES AND FORMS IN THEIR DRAWINGS.

ALTERNATIVE TO TRY:

The child draws various bottles and vases, each with unique shapes and symmetries.

SHOES OF TIME

RULES

The child draws a pair of shoes, focusing on their shapes and framing them aesthetically on paper. The goal is to capture the form and usage of the shoes, paying attention to details like wear and tear.

WHAT WE'RE LEARNING:

This game teaches the child about drawing complex shapes like shoes and the importance of framing them aesthetically. It encourages the child to explore how objects can tell a story through their appearance and condition.

ALTERNATIVE TO TRY:

The child draws a very old shoe, capturing its history and usage through detailed characteristics such as worn-out textures and creases.

NESTED SHAPES EXPLORATION

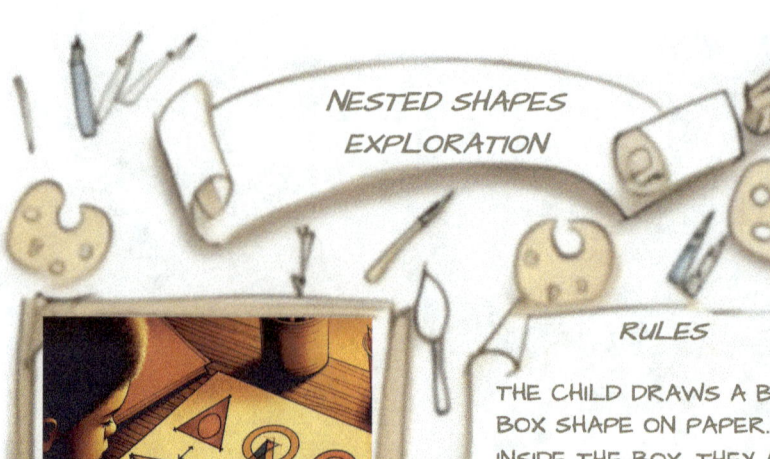

RULES

THE CHILD DRAWS A BIG BOX SHAPE ON PAPER. INSIDE THE BOX, THEY ADD TWO TRIANGLES, AND THEN INSIDE THE TRIANGLES, THEY DRAW TWO CIRCLES, OR ANY OTHER COMBINATIONS OF SHAPES.

WHAT WE'RE LEARNING:

THIS GAME TEACHES THE CHILD TO LOOK AT OBJECTS FROM AN OVERALL GENERAL OUTLINE TO FINE DETAILS.. IT ENHANCES THE CHILD'S ABILITY TO CREATE COMPOSITIONS WITH NESTED SHAPES, UNDERSTANDING SPATIAL RELATIONSHIPS.

ALTERNATIVE TO TRY:

The child experiments with various combinations of nested shapes, such as placing a star inside a circle or a heart inside a square.

THE HAIR DRYER CHALLENGE

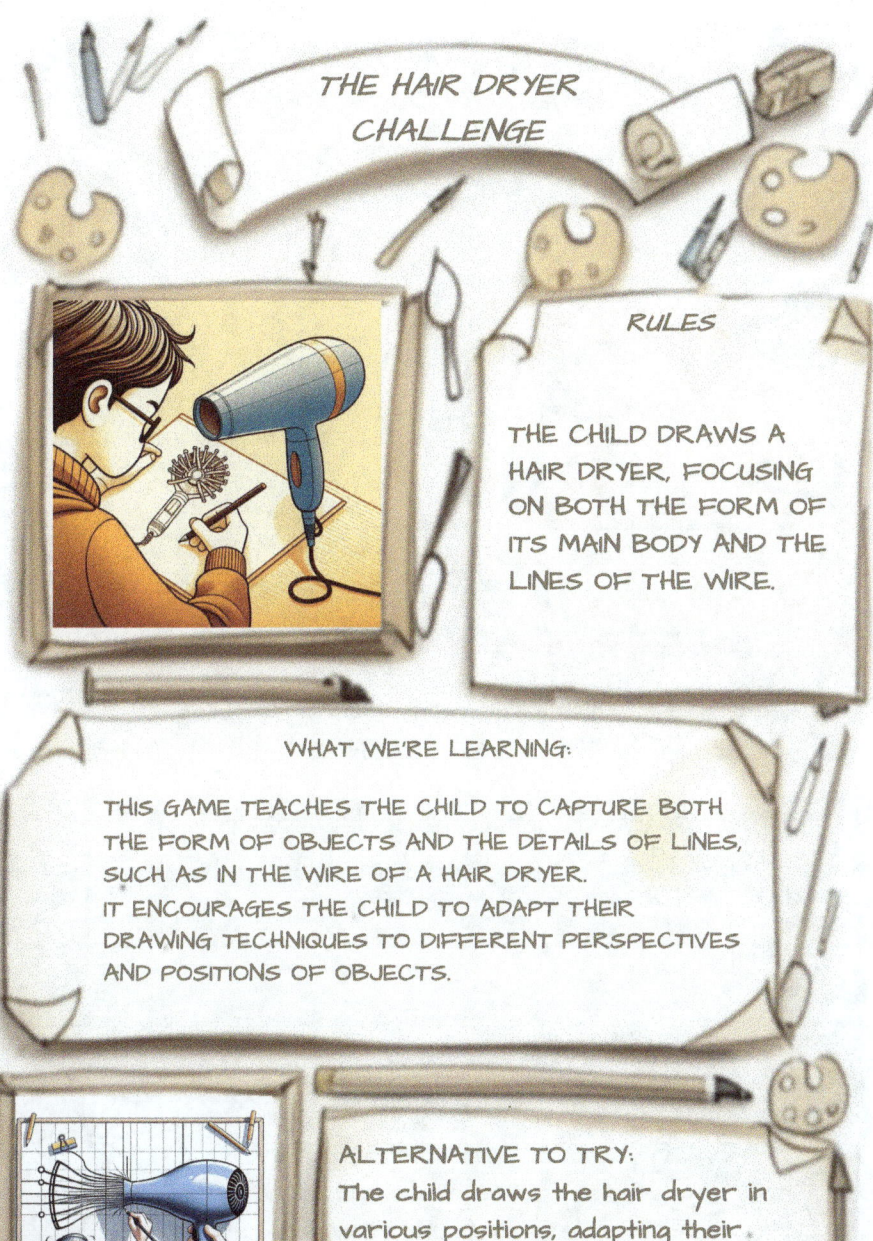

RULES

THE CHILD DRAWS A HAIR DRYER, FOCUSING ON BOTH THE FORM OF ITS MAIN BODY AND THE LINES OF THE WIRE.

WHAT WE'RE LEARNING:

THIS GAME TEACHES THE CHILD TO CAPTURE BOTH THE FORM OF OBJECTS AND THE DETAILS OF LINES, SUCH AS IN THE WIRE OF A HAIR DRYER.
IT ENCOURAGES THE CHILD TO ADAPT THEIR DRAWING TECHNIQUES TO DIFFERENT PERSPECTIVES AND POSITIONS OF OBJECTS.

ALTERNATIVE TO TRY:

The child draws the hair dryer in various positions, adapting their drawing to capture the altered perspectives and details.

CREATIVE CONSTRAINTS

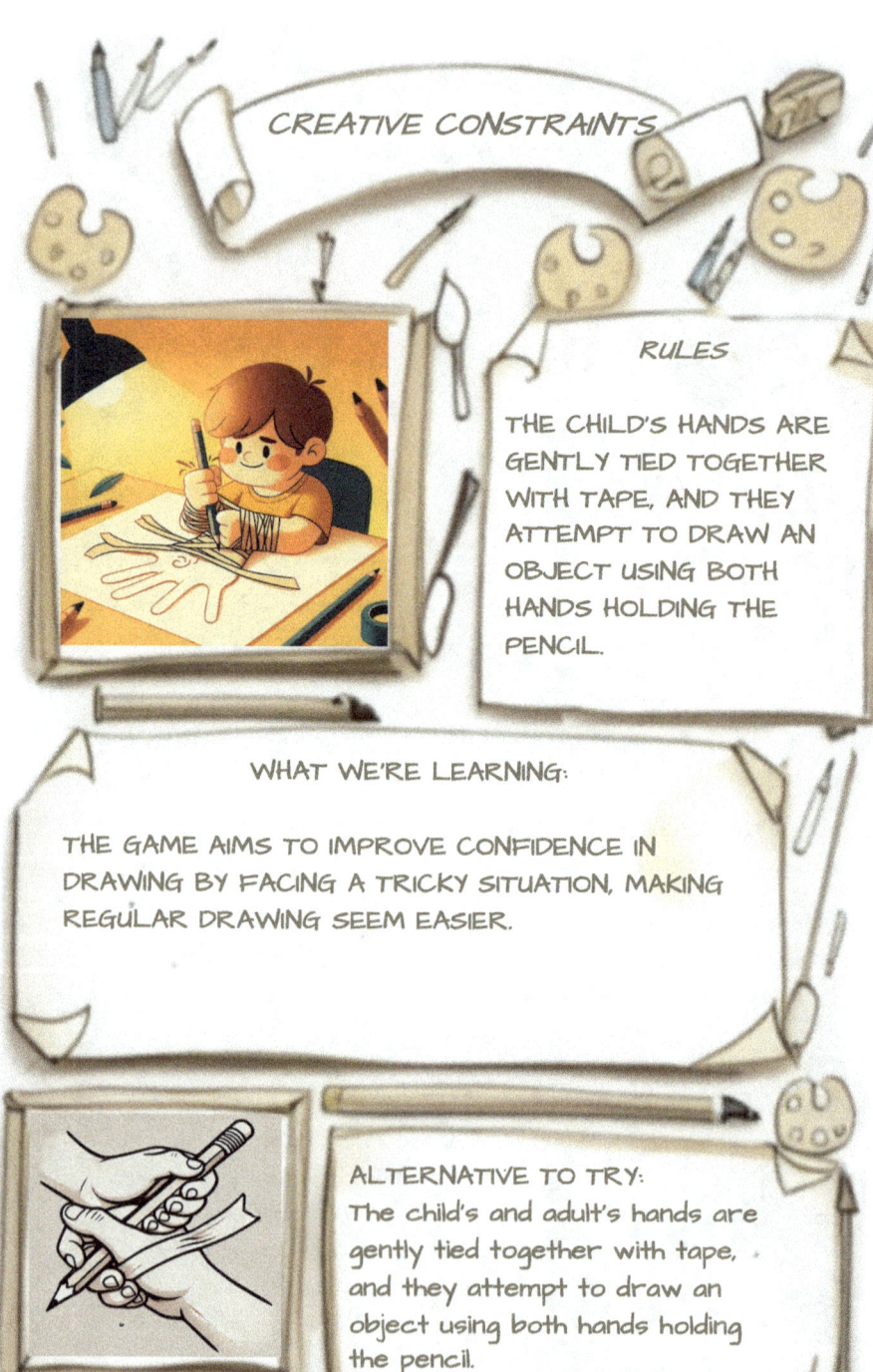

RULES

THE CHILD'S HANDS ARE GENTLY TIED TOGETHER WITH TAPE, AND THEY ATTEMPT TO DRAW AN OBJECT USING BOTH HANDS HOLDING THE PENCIL.

WHAT WE'RE LEARNING:

THE GAME AIMS TO IMPROVE CONFIDENCE IN DRAWING BY FACING A TRICKY SITUATION, MAKING REGULAR DRAWING SEEM EASIER.

ALTERNATIVE TO TRY:

The child's and adult's hands are gently tied together with tape, and they attempt to draw an object using both hands holding the pencil.

BELT SHAPE ARTISTRY

RULES

THE ADULT FOLDS THE BELT INTO A SPIRAL AND PLACES IT ON THE TABLE. THE CHILD OBSERVES AND DRAWS THE SPIRAL SHAPE OF THE BELT, FOCUSING ON ITS COMPLEX FORM.

WHAT WE'RE LEARNING:

THIS GAME TEACHES THE CHILD ABOUT DRAWING COMPLEX SHAPES AND FORMS, LIKE THE SPIRAL OF A BELT AND IT ENHANCES THE CHILD'S ABILITY TO OBSERVE AND ACCURATELY DEPICT OBJECTS FROM REAL LIFE.

ALTERNATIVE TO TRY:

The child folds the belt into a different shape, such as a zigzag or loop, and then draws the new arrangement.

REAL-WORLD SCALE SKETCHING

RULES
PLACE A PIECE OF PAPER ON THE WALL OR EASEL AND ATTACH AN ITEM TO DRAW JUST TO THE LEFT OF IT. THE CHILD DRAWS THE ITEM USING THE SIGHT-SIZE TECHNIQUE, ENSURING THE SCALE ON THE PAPER MATCHES THE REAL SIZE OF THE OBJECT.

WHAT WE'RE LEARNING:
THE GAME TEACHES THE CHILD HOW TO USE THE SIGHT SIZE TECHNIQUE FOR ACCURATE SCALE AND PROPORTION IN DRAWING. THIS TECHNIQUE INVOLVES PLACING THE DRAWING SURFACE AND SUBJECT AT THE SAME HEIGHT AND DISTANCE SO THAT THE ARTIST CAN DIRECTLY COMPARE AND REPLICATE THE SIZE AND PROPORTIONS AS THEY APPEAR FROM THEIR VIEWING POINT.

ALTERNATIVE TO TRY:
Try different objects.

CREATIVE MESS

RULES

THE CHILD CREATES ART USING A BIG MESS OF DIFFERENT MATERIALS, EXPERIMENTING WITH THEIR BEHAVIOR AND BLENDING.
THE GOAL IS TO DRAW AN OBJECT WITHIN THIS COLORFUL CHAOS.

WHAT WE'RE LEARNING:

THE GAME TEACHES THE CHILD ABOUT THE BEHAVIOR OF DIFFERENT MEDIUMS AND SKILLS REQUIRED TO CONTROL THEM AND IT ENCOURAGES CREATIVITY AND EXPERIMENTATION WITH UNCONVENTIONAL MATERIALS.

ALTERNATIVE TO TRY:

The child experiments with watercolors on a very wet surface, observing the unique spreading and blending of the colors.

MIRROR DRAWING

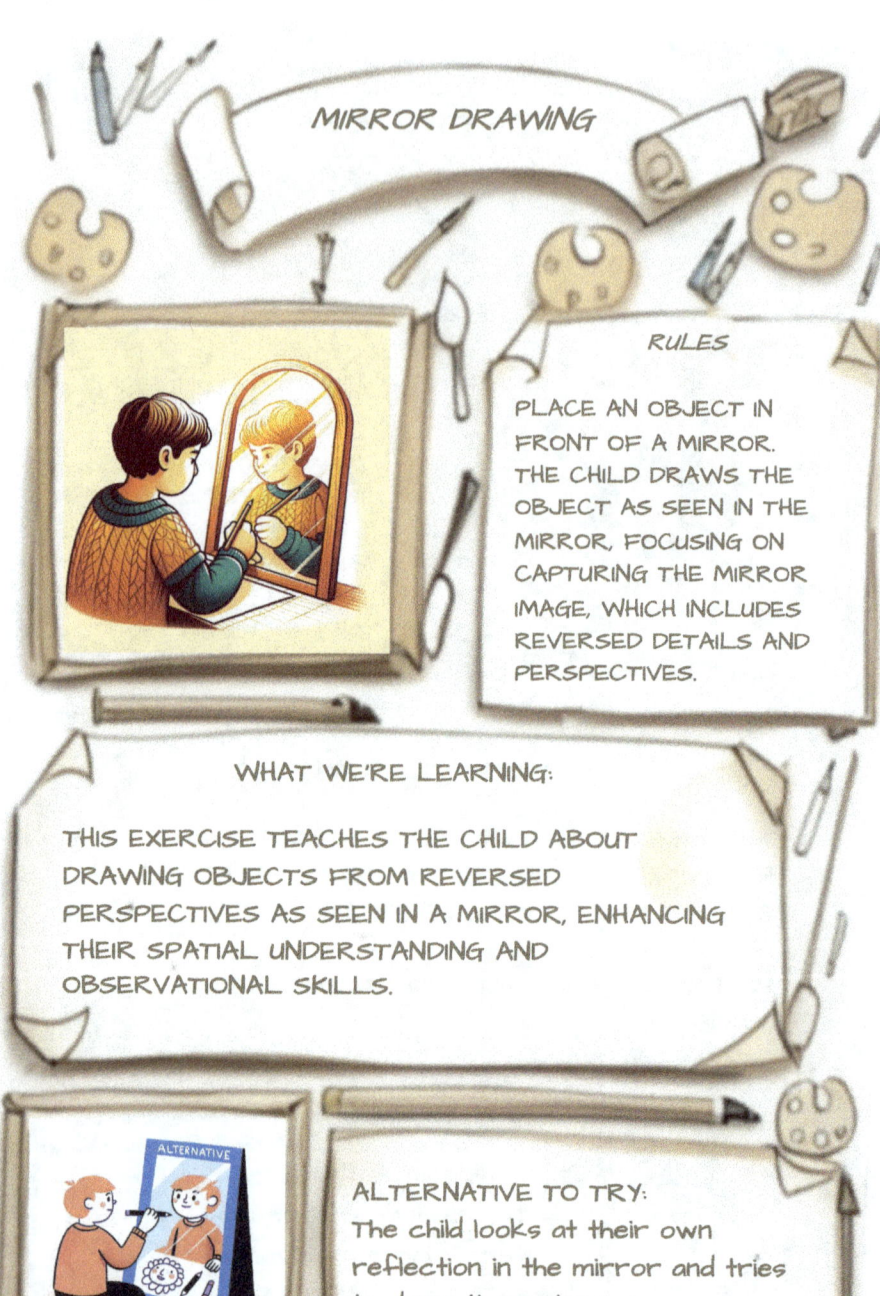

RULES

Place an object in front of a mirror. The child draws the object as seen in the mirror, focusing on capturing the mirror image, which includes reversed details and perspectives.

WHAT WE'RE LEARNING:

This exercise teaches the child about drawing objects from reversed perspectives as seen in a mirror, enhancing their spatial understanding and observational skills.

ALTERNATIVE TO TRY:

The child looks at their own reflection in the mirror and tries to draw themselves.

"**DRAWING GAMES FOR LITTLE OBSERVERS**" IS A COLLECTION OF GAMES THAT EMPHASISE THE IMPORTANCE AND TRANSFORMATIVE POWER OF DRAWING IN EARLY CHILDHOOD EDUCATION. DRAWING ON PERSONAL EXPERIENCES AND YEARS OF TEACHING HIS CHILDREN, THE AUTHOR PRESENTS AN INNOVATIVE, FUN, AND SIMPLE METHOD FOR TEACHING DRAWING AND ALSO UNDERSCORES THE CRUCIAL SKILL OF OBSERVATION. RATHER THAN FOCUSING ON MERE REPLICATION OF PHOTOGRAPHS OR INSTRUCTIONS, THIS BOOK SEEKS TO NURTURE THE CAPACITY TO OBSERVE THE REAL WORLD AND TRANSLATE THAT VISION ONTO PAPER. IT ADVOCATES FOR THE IMPORTANCE OF DRAWING AS A FUNDAMENTAL SKILL THAT GOES BEYOND ARTISTIC EXPRESSION, HIGHLIGHTING ITS ROLE IN COGNITIVE DEVELOPMENT, COMMUNICATION, AND ENHANCING CULTURAL LITERACY. THROUGH A SERIES OF FLEXIBLE EXERCISES, READERS ARE ENCOURAGED TO APPROACH DRAWING AS A JOYFUL EXPLORATION, EMPHASISING THE PROCESS OF SEEING AND UNDERSTANDING OVER PERFECTION.

THE AUTHOR:
GUIDO SALIMBENI
https://www.linkedin.com/in/guidosalimbeni/

www.ingramcontent.com/pod-product-compliance
Lightning Source LLC
Chambersburg PA
CBHW070118230526
45472CB00004B/1320